MASTERING
COLOR

MASTERING
COLOR

Published by Time-Life Books in association with Kodak

MASTERING COLOR

Created and designed by Mitchell Beazley International
in association with Kodak and TIME-LIFE BOOKS

Editor-in-Chief
Jack Tresidder

Series Editor
Robert Saxton

Art Editors
Mel Petersen
Mike Brown

Editors
Louise Earwaker
Richard Platt
Carolyn Ryden

Designers
Ruth Prentice
Eljay Crompton

Picture Researchers
Veneta Bullen
Jackum Brown

Editorial Assistant
Margaret Little

Production
Peter Phillips
Androulla Pavlou

Historical consultants
Brian Coe
Fred Dustin

Written for Kodak by John Farndon

Coordinating Editors for Kodak
Paul Mulroney
Kenneth Oberg
Jacalyn Salitan

Consulting Editor for Time-Life Books
Thomas Dickey

Published in the United States
and Canada by TIME-LIFE BOOKS

President
Reginald K. Brack Jr.

Editor
George Constable

The KODAK Library of Creative Photography
© Kodak Limited. All rights reserved

Mastering Color
© Kodak Limited, Mitchell Beazley Publishers,
Salvat Editores, S.A., 1985

Library of Congress catalog card number
ISBN 0-86706-243-6
LSB 73 20L 15
ISBN 0-86706-242-8 (Retail)

Contents

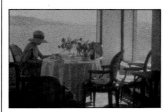

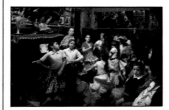

THE CHALLENGE OF COLOR

The quality of color film and photographic equipment is constantly being improved. Amateurs as well as professionals can now achieve color images that are technically superlative and that have a clarity and intensity of hue not available from earlier color films. But mastering color photography means more than simply knowing how to use bold colors. As this book shows, several of the early processes yielded extremely delicate effects that have been used to create some of the most beautiful color pictures ever made.

This book explores both the fascinating history of color photography and the way you can control color if you know how modern color processes work. It also looks at the way in which colors behave and shows how you can take special measures to bring out the quality you want, as in the vivid greens in the picture opposite.

Response to color is a highly individual matter. Not only do people see colors differently, they also value them differently and are affected by them in diverse ways. In a photograph, the way you treat color will help define the composition and establish a definite mood. The portfolio of pictures on the following nine pages shows some of the many ways this is accomplished – and how photographers past and present have used color for individual and original expression in their work.

A mature cedar trunk in the Olympic National Park, Washington, provides a muted contrast to the brilliant greens of the plants at its base. The photographer used a No. 10 red color compensating filter to compensate for green light through the foliage, which could have given a cast to the pure white flower on the forest floor.

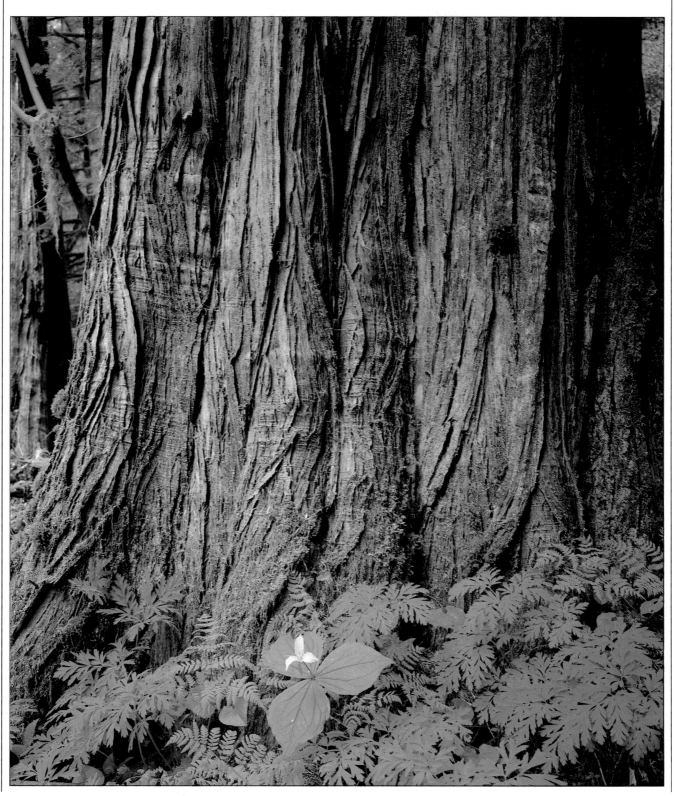

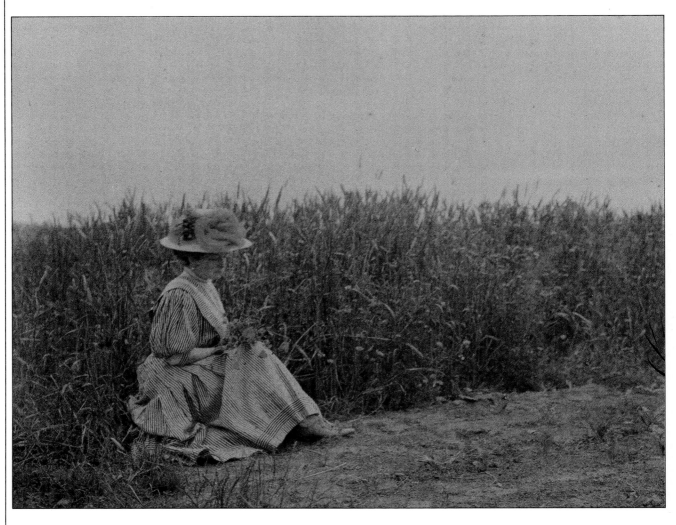

A young woman rests with her bouquet of wild flowers. This early 20th-Century view by Antonin Personnaz shows how quickly some of the early photographers mastered new developments in color to evolve an individual style; here, the soft clear colors of an Autochrome plate create an image that recalls French Impressionist paintings.

The stylized pose and haughty profile of the model opposite typify the fashion shots of the 1930s and the 1940s, an era in which photographers began to use color to suggest elegance and glamor. The theatrical approach to lighting in this 1945 picture is characteristic of the celebrated photographer, Cecil Beaton.

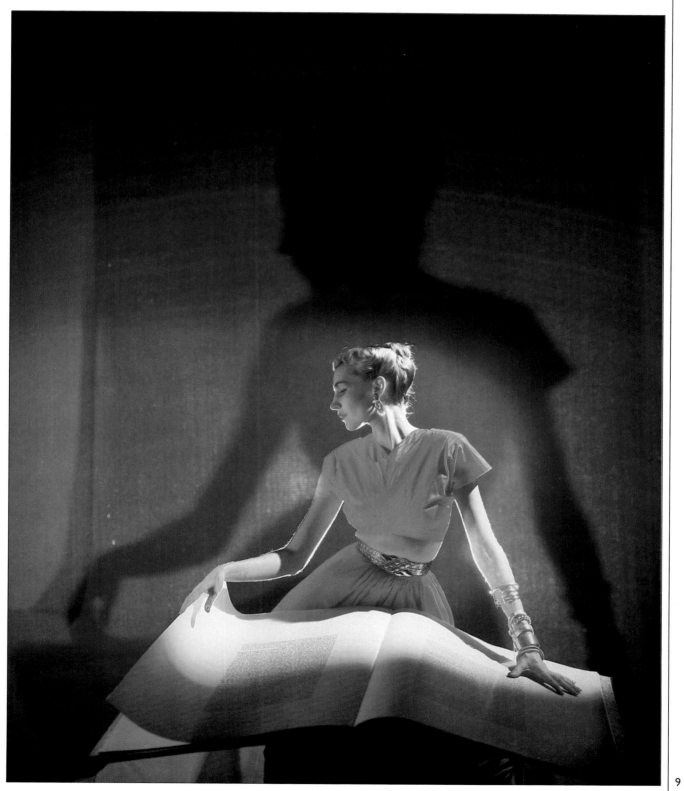

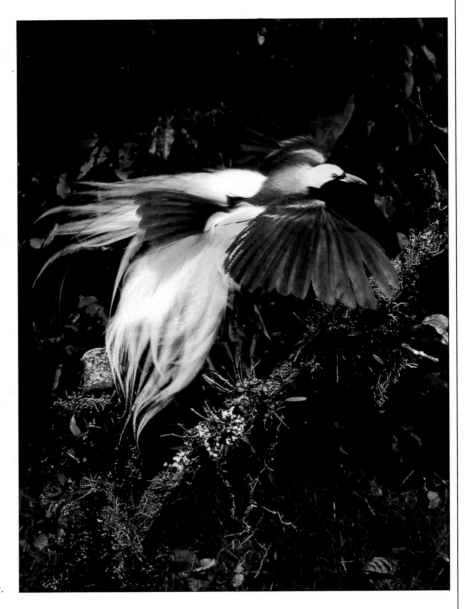

A tropical bird fans out its fine plumage as it takes flight. The picture, demonstrating a sure appreciation for color and compositon, was taken for Life *magazine by Larry Burrows. The bird's movement was recorded as a slight blur, which softened and muted the colors.*

The famous matador El Cordobés daringly foils a bull with an elegant swish of his cape in a historic picture taken for Life magazine in 1965 by Loomis Dean. The pink cape and the gold brocade of the bullfighter's costume contrast with the animal's thundering black shape, creating a powerful image that is full of tension.

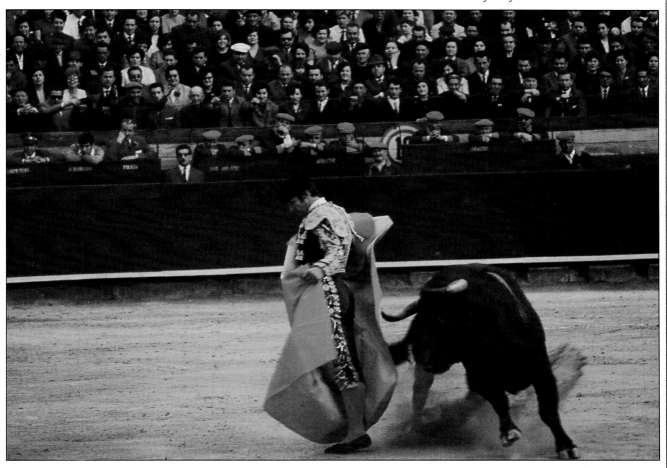

The selection of subjects and treatments on these two pages shows the versatility and superb quality of today's 35 mm slide films. To exploit the full range of creative possibilities, you need to master precision metering and learn how to control the appearance of a slide by modifying exposure, or by using filters.

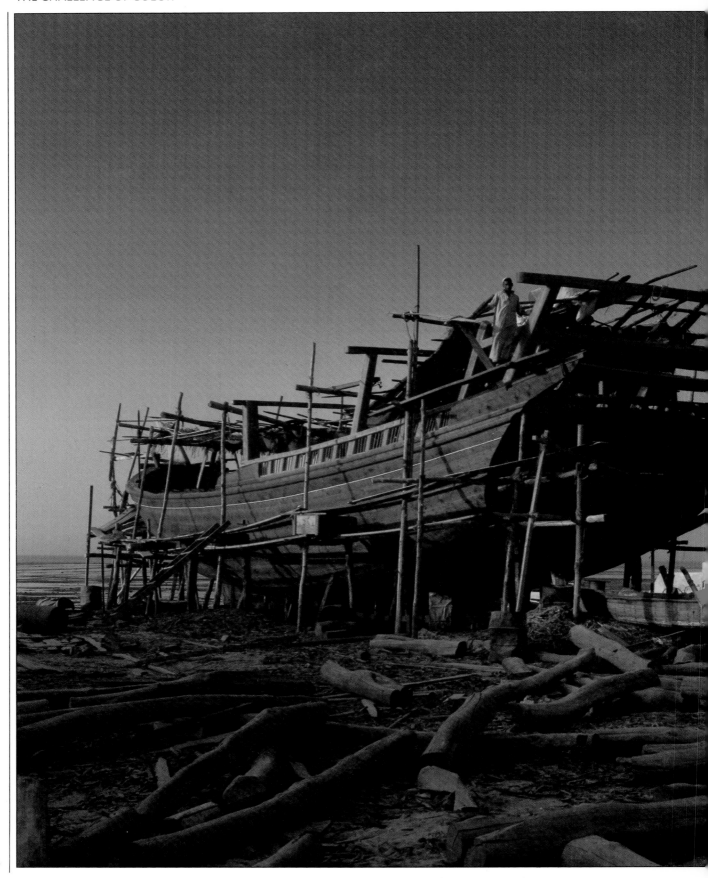

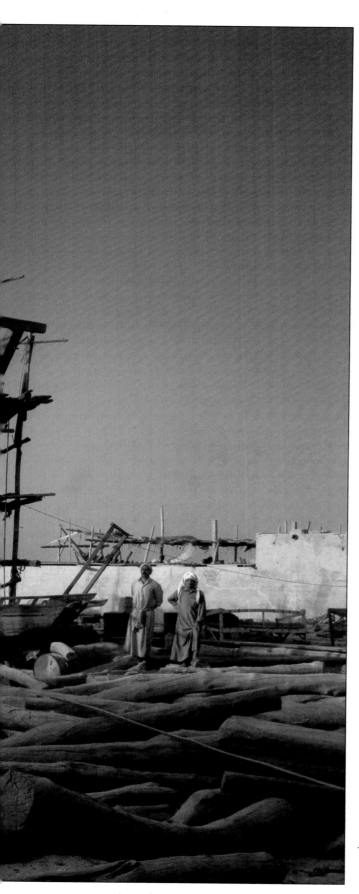

In warm evening light, *a ship under construction in Morocco acquires rich tones, while the cloudless sky takes on a beautiful purple hue. To capture this extraordinary lighting effect accurately on daylight-balanced medium-format color film, the photographer took a reading with a color temperature meter and used an 80C filter to prevent the scene from looking too red.*

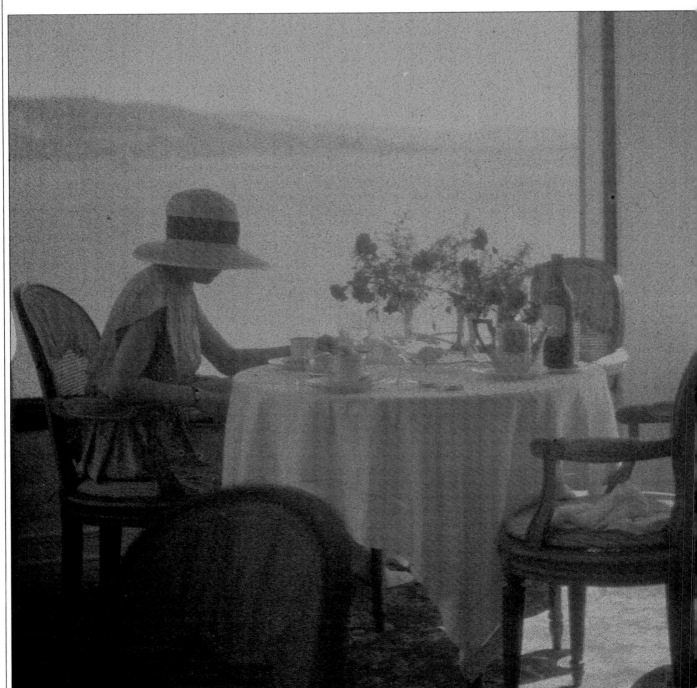

CHASING RAINBOWS

By 1860 the technology of black-and-white photography was well past its infancy, but no one had yet been able to produce a realistic and stable color image. And many had tried: some experimenters had spent fortunes in the attempt to photograph the world in its true colors. However, there had been enough near misses to give hope to the dedicated few who persisted in chasing rainbows.

The story of color photography in the last four decades of the 19th Century is one of accelerating technological discoveries and a sense of cumulative excitement, even though there were many false starts. Key figures in this narrative testify to an international breadth of interest: James Clerk Maxwell in London; Charles Cros, Louis Ducos du Hauron and Gabriel Lippmann in France; Frederic Ives in Philadelphia; John Joly in Ireland. The inventors who finally set color photography firmly on the way to becoming a popular medium were the Lumière brothers of Lyons, France, whose achievements in the early 1900s led to images in colors that not only were true to life but at best could be beautifully atmospheric, as in the picture at left.

However, the discovery of color photography as we know it today did not occur until the early 1930s, when massive advances were made under the corporate banners of Kodak in America and Agfa in Germany. The achievements of scientists working for these two firms prepared the way for all future refinements, including high-speed color film for action photography and the magic of instant color.

A teatime scene in a room with an ocean view inspired French photographer Jacques-Henri Lartigue to take this delicate picture in 1920, using the highly popular Autochrome process invented by the Lumières.

17

Before color

The quest for color began almost with photography itself. Joseph Nicéphore Niepce, a French lithographer, who took the earliest surviving photograph in the 1820s, was not content with his achievement, but spent many years looking for a means of creating a color image. As early as 1816, Niepce succeeded in registering at least some colors, but he could not fix them permanently. For half a century, photographers and scientists strove for a process that would both reproduce and fix the colors of nature in a photograph. Again and again, a breakthrough seemed close. One such incident occurred in 1851, when a New York Baptist minister, the Reverend Levi Hill, announced the Hillotype, a way of obtaining color photographs on plates. But Hill could neither explain his process nor

repeat it satisfactorily. A year later Niepce's nephew, Niepce de St.-Victor, exhibited his color plates in Paris, to wide acclaim. But the plates faded within a few days. The only way to keep the colors was to store the plates in total darkness.

If the would-be inventors were impatient for color, so too was the public. Early photographic subjects were often portraits, which had a tendency to look dull in monochrome. This was particularly true of daguerreotypes, which were made on copper plates and had a cold, blue, metallic appearance. Lacking the means to produce color photographically, many photographers added colors by hand. The portraits here, all taken before 1860, show some of the hand-coloring techniques employed.

The choice of coloring methods for a photograph

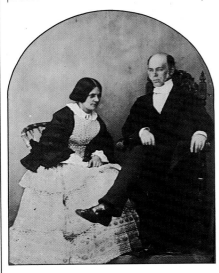

The portraits shown here, all probably from the 1850s, are part of the photographic collection in London's Victoria and Albert Museum. With the exception of the soldier, the hand coloring is very subtle, but the colors may well have faded over the years. The two portraits on this page are hand-tinted paper prints: the delicate flesh tints were probably applied with watercolors. On the opposite page, the two smaller images are ambrotypes. Often, the coloring of such images was restricted to gilding the sitter's jewelry; in the top picture, however, the background was also skillfully tinted. The soldier's picture shows how applying color too thickly produced an unnatural result. The portrait at far right is a daguerreotype; subtle tinting removed some of the characteristic cold tinge.

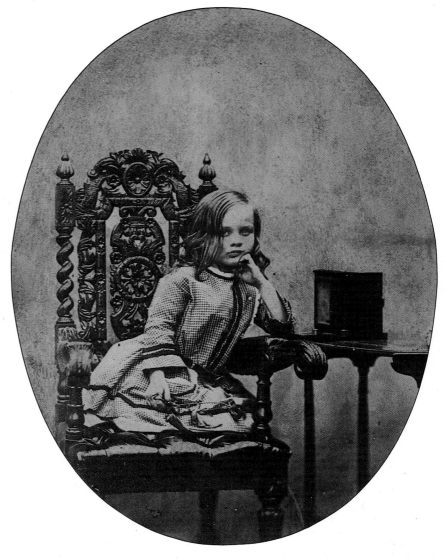

was partly determined by the materials used to make the image – a daguerreotype, an ambrotype or a print on paper. A daguerreotype image could easily be rubbed off the metal plate, so color had to be applied very delicately. Generally, fine powder colors were dusted on and set by breathing on the plate. An ambrotype, made by placing the negative on a glass plate backed by black material, could also be tinted with dry colors, then varnished.

Prints could be colored with watercolors or oil paints. In some cases, the photographic origin was almost entirely disguised, so that a portrait looked more like a painting. At the other extreme, hand coloring could be done so subtly that it was scarcely discernible; the aim was only to remove the pallor of a subject's skin with a vestige of flesh tint.

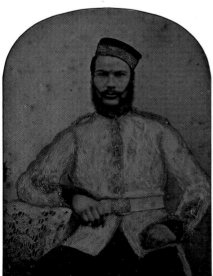

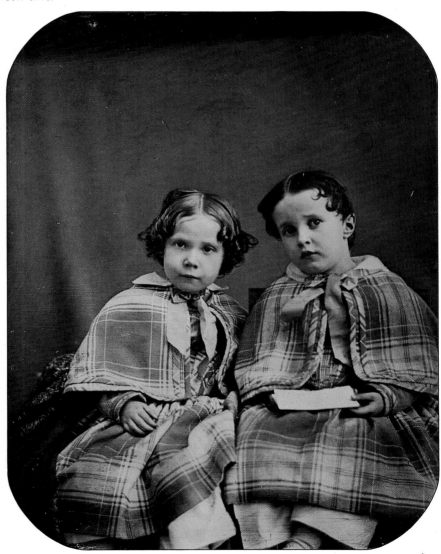

The first color image

By the end of the 1850s, photographers were beginning to despair of ever being able to take pictures in color. Then, in 1861, came an apparent breakthrough. James Clerk Maxwell, a young Scottish physicist, gave a lecture on human color vision, and illustrated it with a color photograph.

Strangely enough, Maxwell was not interested in advancing photography at all; his demonstration was an attempt to put into practice a theory propounded by English scientist Thomas Young in 1806. Young believed correctly that the eye responds to only three colors of light: red, green and blue. Every other color in the spectrum is a mixture of these primary colors. From this, Maxwell reasoned that it should be possible to re-create all the colors of a scene in a photographic image by adding together red, blue and green light in the right proportions. Working with photographer Thomas Sutton, Maxwell succeeded in projecting a color photograph of a tartan ribbon onto a screen before an excited audience at the Royal Institution in London. His method, described below, involved using three magic lanterns and filters that consisted of glass troughs filled with colored liquid. The image was poor because, even without filtration, the lanterns of the day were dim. But the result was, in Sutton's words, "a sort of photograph of the ribbon . . . in the natural colors."

Maxwell's 1861 demonstration established the principle of the three-color system, on which modern color processes are founded. But his creation of a color image could not be repeated at the time, because the photographic materials then available were sensitive only to blue light. Indeed, had it not been for two coincidences, Maxwell would have obtained no image through the green and red filters. First, the red dyes in the ribbon reflected ultraviolet radiation, to which the plate was sensitive. And second, the green filter admitted just enough blue-green light to form an image.

How the first color image was made
To reproduce the colors of an original subject, Maxwell asked Sutton to take three separate photographs of a ribbon, each through a different colored filter. Glass slides made from the resulting three different black-and-white images were placed in "magic lanterns," carefully positioned to superimpose the projected images as diagrammed below. When the slides were projected through filters of the same primary colors, the superimposed images (individually simulated at right) formed the colors of the ribbon (opposite page).

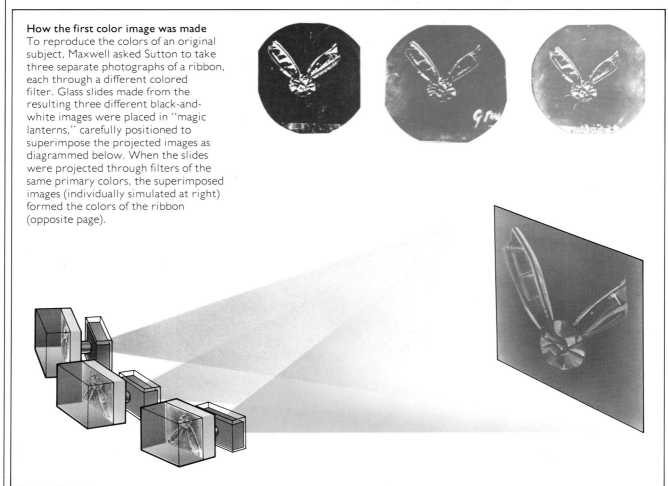

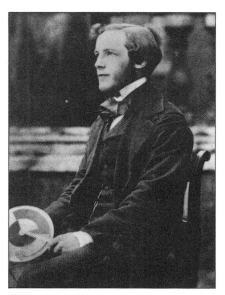

James Clerk Maxwell holds a spinning top that he designed for his experiments with color vision. The primary colors, painted on the top, produced gray when the top was spun. Maxwell is credited with establishing the principles of color photography – although the successful demonstration that produced the first color image was actually a lucky fluke.

Maxwell's tartan ribbon (below), which made history as the world's first color photograph, was based on the principle known as additive synthesis. This was to play a major part in photography until the 1930s, and is used today to create the colors of television.

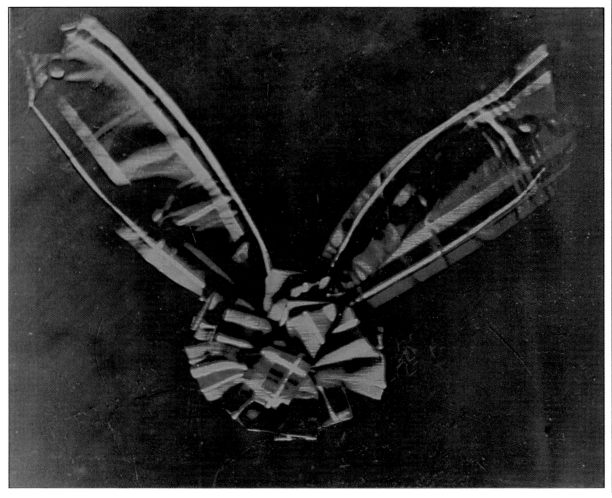

A picture on paper

Louis Ducos du Hauron

Charles Cros

At about the same time as James Clerk Maxwell was developing his ideas on color vision in London, a young Frenchman, Louis Ducos du Hauron, was busy formulating an alternative three-color process. Whereas Maxwell's system was additive – the colors in the image were built up on the projection screen by adding light in each of the three primary colors – du Hauron proposed a subtractive process.

The starting point was the same: three black-and-white images of a scene, exposed through red, green and blue filters, respectively. The next step involved a substance using bichromated gelatin. Du Hauron mixed together pigments, gelatin and light-sensitive

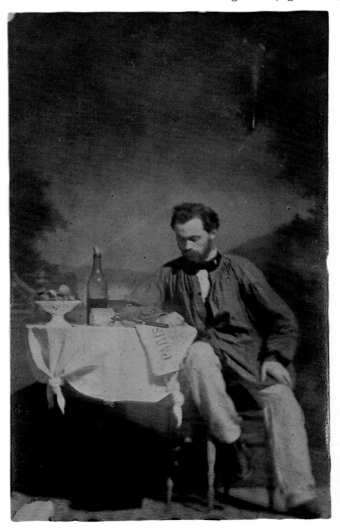

A man reading a newspaper (above)
was the first color portrait taken by du Hauron,
on August 7, 1876. Despite the relaxed pose
of the sitter, the photograph required
a 90-second exposure.

bichromate crystals, and coated sheets of tissue with the mixture. He made three different colors of tissue, one with yellow, one with magenta and one with cyan pigment. To make the color print, he exposed each of the three negatives onto the tissue coated with the color complementary to the filter used to make the negative. He then washed each tissue in warm water. In each case pigmented gelatin adhered to the paper in unexposed areas and washed off in exposed areas. Du Hauron then transferred the images on the tissues one by one onto a sheet of white paper. In principle, this subtractive process is exactly the same as the one used today.

By the time du Hauron was ready to reveal his discovery, a fellow countryman named Charles Cros had independently reached similar conclusions. It was Cros who made their process public at a meeting of the Société Française de Photographie in Paris in May 1869. These subtractive processes, like Maxwell's additive method, could not be put to immediate practical use, because photographic materials were sensitive only to blue light. But in 1873, Dr. Hermann Vogel discovered green-sensitive dyes; and three years later, du Hauron succeeded in making his first color portrait on paper (below, far left).

This view of Angoulême is an early landscape print by du Hauron. After making three exposures through primary filters, he made complementary positives and superimposed them on white paper.

The old stonework of a building in the historic French town of Agen is revealed in detail. The picture was taken in 1877 but, more than a century later, the colors remain surprisingly clear.

Color in 3-D

Practical color photography in the 1880s was still out of the public's reach, yet the experiments of Maxwell and du Hauron had made it seem tantalizingly close. It was the ingenuity of an American inventor, Frederic Ives, that took color photography out of the laboratory and into the Victorian parlor. Ives had a genius for turning theory into practical techniques, and as early as 1888 he had displayed a streamlined commercial version of Maxwell's cumbersome three-color experiment. Seven years later, he began to sell a range of devices for the taking and viewing of color photographs.

The first of these was the Kromskop viewer, which housed a clever arrangement of colored reflectors, as diagrammed opposite. Peering through the eyepiece of the machine, the viewer saw three black-and-white pictures united into a single, vividly colored image. On some models, each separation in the Kromskop was a stereo pair, so the user saw the subject in color in three dimensions.

Ives's Kromskop was an instant success: at social functions it quickly became all the rage to pass around a viewer with a selection of pictures, usually commercially made "Kromograms" of flowers and exotic views. Such pictures were made with a "one shot" camera, invented by Ives, that used an arrangement of mirrors and filters to make the three color separations in a single exposure. Those who wanted to make their own Kromograms could buy an "Ives repeating back" that fitted onto a normal camera. The device held a long plate, which the photographer slid across the back of the camera to make the three exposures in quick succession. The practical difficulties proved too much for most amateur photographers, though, and most people were content to buy the pictures ready-made.

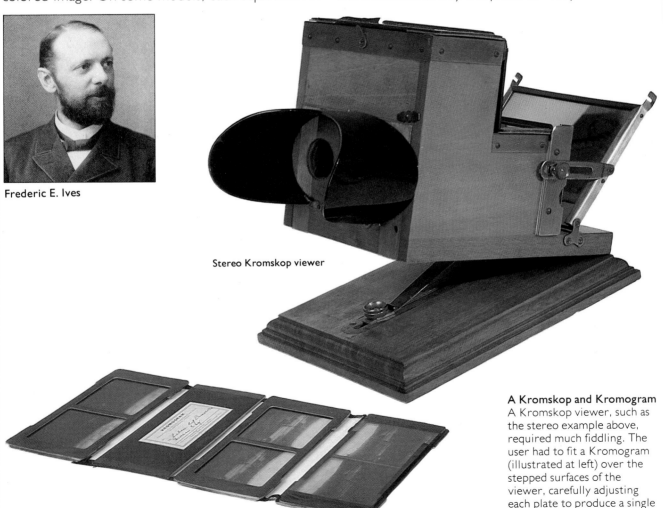

Frederic E. Ives

Stereo Kromskop viewer

Stereo Kromogram

A Kromskop and Kromogram
A Kromskop viewer, such as the stereo example above, required much fiddling. The user had to fit a Kromogram (illustrated at left) over the stepped surfaces of the viewer, carefully adjusting each plate to produce a single color image.

Viewing Kromograms

Kromograms were not themselves colored – they were sets of three black-and-white images, or three stereo pairs, as shown here. Each image, or pair, was slightly different, because each had been taken through a different colored filter. To "replay" the hues of the scene, the images had to be colored and superimposed. The Kromskop achieved this with a complex set of filters and reflectors, as diagrammed at right.

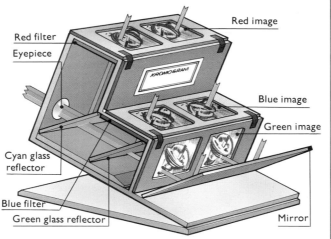

Red filter
Eyepiece
Red image
Blue image
Green image
Cyan glass reflector
Blue filter
Green glass reflector
Mirror

KROMOGRAM

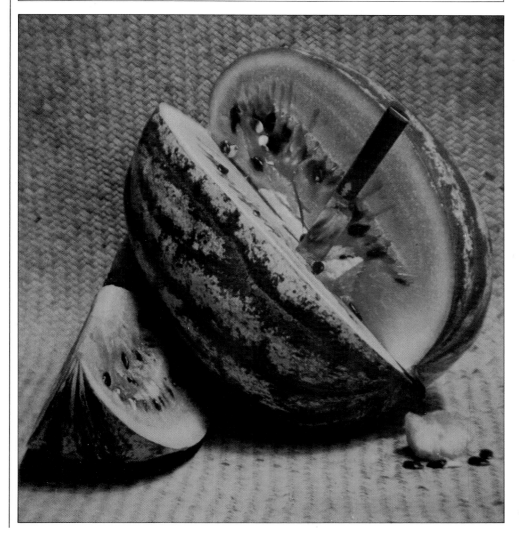

A watermelon regains its natural hues when the three black-and-white images that make up the picture are viewed through the Kromskop viewer. Images like this now seem mundane, but to a public that had seen only monochrome photographs, Kromograms were startling and new.

25

Color from light patterns

In 1891 Gabriel Lippmann, a physics professor at the Sorbonne in Paris, perfected a direct color process based on lightwave interference. This phenomenon had been noted in 1868 by the German physicist Wilhelm Zenker, in relation to the bright colors that appeared briefly on photographic plates with polished, reflective surfaces, such as daguerreotypes. The interference phenomenon occurred when waves of incoming light met light reflected back by the polished surface. By putting this theory to use, Lippmann produced some of the most beautiful color photographs ever made.

Lippmann made a photographic emulsion with a very fine grain to coat a glass plate. This coating was backed by a layer of mercury, which acted like a mirror to incoming light waves. The pattern of "standing" waves was recorded in the emulsion as a latent image. When the plate, after processing, was viewed in reflected light, a positive image appeared with all the colors of the original subject precisely reproduced. The colors were startlingly brilliant, with an extraordinary iridescence.

There were two serious disadvantages to the Lippmann method. First, because of the ultrafine grain in the emulsion, lengthy exposures of several minutes were needed to take the photographs. Second, even when the image could be projected onto a screen with sufficient reflected light, the result had to be viewed from just the right angle for the colors to appear.

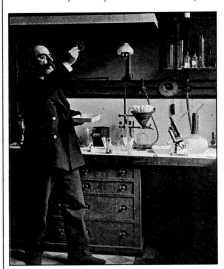

Gabriel Lippmann is observed experimenting in his physics laboratory in the photograph at left. Lippmann's application of light interference to reproduce all the colors of nature was rewarded by a Nobel Prize in 1908.

A Lippmann plate holder

The plate holder at right was specially devised for the Lippmann process. The photographer inserted a plate into the plate holder, which he then loaded into a camera. Next, he introduced mercury into the holder through its upper pipe. He lifted the holder's built-in sheath and opened the shutter to make the exposure, then quickly drained off the mercury from the lower pipe: the mercury would damage the emulsion if left too long in contact with the exposed plate.

The Lippmann process

The iridescent colors of Lippmann's images were produced in the same way as the colors we see in oil on water, as shown at left, or in a soap bubble. Light waves falling from the subject onto the reflective surface of the mercury interfered with waves reflected back from the surface to form stationary or "standing" waves, rather as the vibration of a speeding train makes a static pattern of waves on the surface of a passenger's cup of coffee. The standing waves made by different color wavelengths exposed the photographic emulsion to form a multi-layered silver image. After processing, the color wavelengths of the original exposure were re-created by viewing the plate through a transparent reflector held at a precisely judged angle.

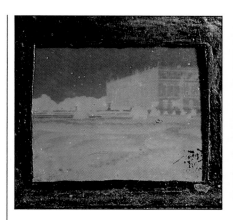

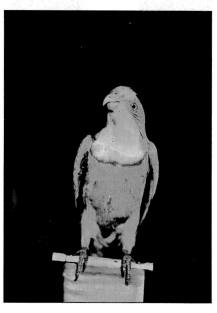

The Palace of Versailles and its gardens (below) was photographed toward the end of the 19th Century by the Lippmann process. The picture above shows the effect of looking at the same Lippmann plate from a different angle of view: all color is drained from the image.

A parrot on a perch glows with luminous color against a black background (left). Dr. Richard Neuhauss, one of many enthusiasts who experimented with Lippmann's direct color process, was the photographer of this famous Lippmann plate, produced in 1899.

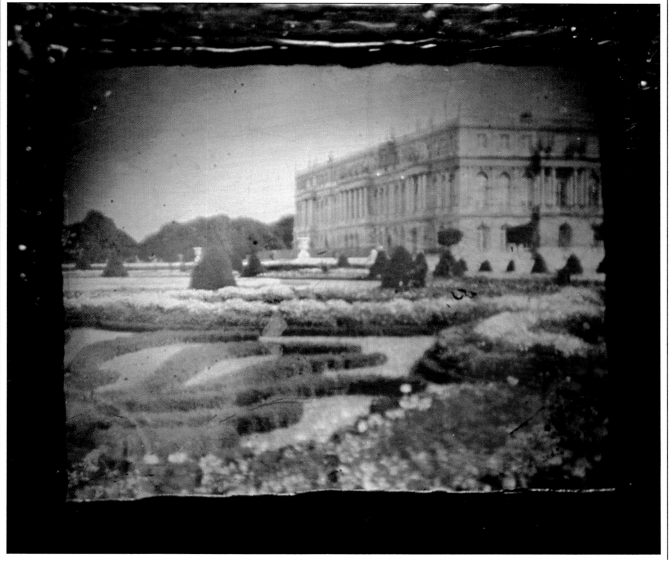

Color from lines

Most 19th Century color processes required special cameras or forced the photographer to make three separate exposures through red, green and blue filters. Consequently, photography was often difficult and expensive. However, in the 1890s an ingenious way to get around this problem emerged – the use of just one plate instead of three, and of colored filters placed on top of the light-sensitive emulsion rather than over the lens.

Professor John Joly of Dublin University was the first to take this idea to a practical conclusion. To make his "filters," he ruled a glass plate with red, green and blue lines, each less than 1/200 inch wide. He then pressed this striped glass screen against the photographic plate before making an exposure in an ordinary camera. Beneath the red lines, the emulsion recorded only the red light; similarly, blue and green light exposed the plate only beneath lines of a corresponding color. After the line screen was removed, the plate was processed and contact-printed onto a second plate, to yield a positive transparency. Pressing this against the line screen restored the colors to the picture, as shown below.

Improved line-screen processes soon followed

The Joly color process
Uniform parallel lines crossed all pictures created with the Joly color process, building up the image in much the same way as does a modern color TV. Magnified 45 times, as at right, the image's structure is clearly visible. The picture was first recorded in black-and-white; colors appeared only when this monochrome image was reunited with the striped screen used in taking the picture.

×45

Magnified portion of screen

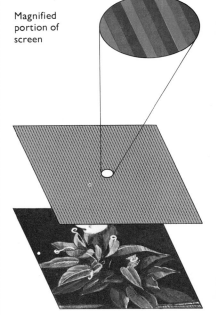

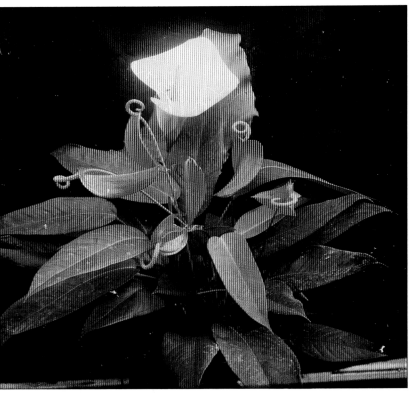

Pressing the Joly line screen (top) into contact with a positive transparency that had been exposed through a similar screen (above) produced a full color image (right).

Joly's. Later systems, such as the Paget plate shown below at right, made possible shorter exposures, simplified processing and produced brighter colors. But the most important improvement of all was the combined plate, which united the light-sensitive emulsion and ruled screen on a single sheet of glass or film. This did away with the painstaking routine of lining up the processed picture and colored screen, and yielded a color image with very fine patterns that were virtually undetectable unless greatly magnified. In the combined-plate form, line-screen processes survived well into the 1950s.

The Paget process
As screen plates evolved, mosaics of color replaced simple lines. The Paget process used a checkerboard pattern of red, green and blue squares, as shown below. This color screen had a much finer texture than the earlier Joly version, considerably improving picture quality, as shown in the delicate studio portrait at right, taken around 1913. Paget plates were discontinued in the early 1920s.

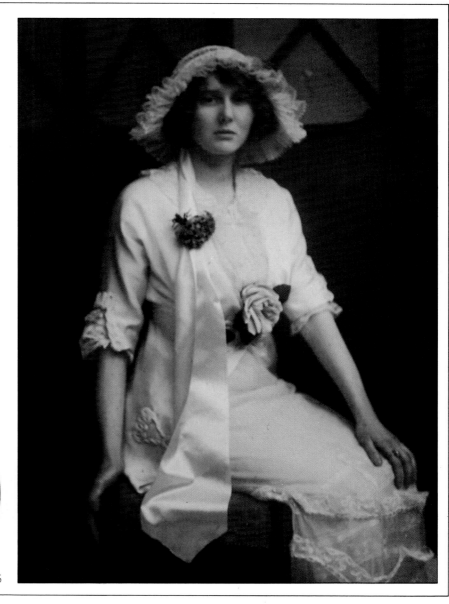

×45

Color from dots

"From today, the world will be color mad!" exclaimed photographer Alfred Stieglitz when he first encountered the Autochrome process in 1906. The world did not immediately live up to Stieglitz' expectations, but nevertheless Autochrome plates provided the first really popular and practical color process. They were the invention of two French brothers, Auguste and Louis Lumière. Like the Joly and other line-screen plates, the Lumières' brainchild was an additive screen process. But instead of being inked with lines, the glass plates were speckled with millions of colored dots, like tiny filters, to separate light into its primary hues. The dots were grains of potato starch, dyed red, green and violet; this screen was coated onto the plate and covered with a light-sensitive emulsion.

Photographers simply loaded the Autochrome plates into their cameras with the glass side facing the lens. Thus, light reached the emulsion only after passing through the multicolored filter layer, which is shown, greatly enlarged, below. Processing produced a positive image in black-and-white, but because the viewer saw this image through the colored specks, the pictures appeared in full, if muted, color. The system sounds somewhat crude, but it yielded remarkably good results. And although the emulsion speed was only about ISO $\frac{1}{2}$, exposure times were brief by the standards of the day. For example, a sunlit landscape needed only one second at f/5.6. But the success of Autochromes was due not so much to its speed as to its low cost, and the fact that plates could be used in ordinary cameras.

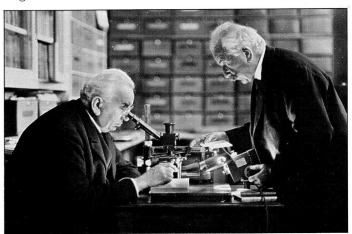

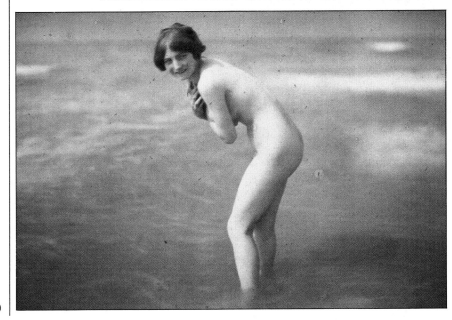

Auguste and Louis Lumière, who devised the Autochrome process, are at work in their laboratory in Lyons, France, in this double portrait. They patented their Autochrome screen plate in 1904 and introduced it to a delighted public three years later.

An Autochrome plate
This magnified view (150x) clearly shows the random pattern of minute potato-starch grains that gave the pictures their delicate colors. The grains are so small – about 4 million per square inch – that they are invisible to the naked eye. The specks of color visible in un-magnified Autochrome pictures are not individual grains, but clumps of 10 or 12.

A nude paddling at the seaside (left) glances coyly over her shoulder in an Autochrome plate taken in 1912 at Astrières in France. Experts agree in attributing this plate to a photographer named Antoine Meys.

The Lumières' mother and Auguste's daughter pose in this picture taken by Louis. The subdued hues of Autochrome plates give the image a Victorian air, yet the photograph was taken in 1915.

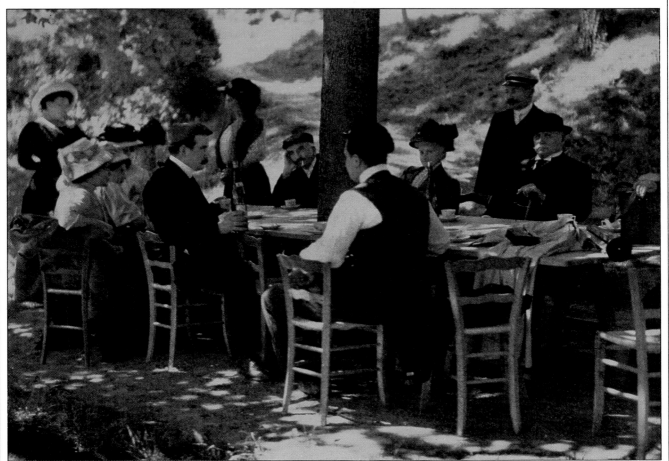

A garden lunch, attended by the Lumière family and friends, conveys something of the Lumières' lifestyle. This Autochrome plate was probably taken by Louis – Auguste appears in the picture, standing at the right.

Color synthesized

In 1917 two classmates from Riverdale Country School in New York City went to see a movie billed as being in color. The hues were disappointingly muddy and unnatural. So the boys, Leopold Mannes and Leopold Godowsky, resolved to do better themselves. Thus began a partnership that led to the creation of Kodachrome, the world's first truly effective color film, which unlocked the world of color photography to millions.

After graduating from college, Mannes and Godowsky worked as musicians while carrying out photographic research in their spare time in make-shift labs. They soon shifted their interest from an additive process to the subtractive principle and the "integral tripack" – a film coated with three layers of emulsion, each sensitive to one of the primary colors. But although they succeeded in diffusing dyes into the emulsion layers of a film, they were able to do so only with two layers, not three.

Then, in 1924, Mannes and Godowsky read of proposals that had been put forward by the German chemist Rudolf Fischer in 1912. His idea was to include, in each layer of the film, "dye couplers" that would react with the processing chemicals to form dyes. Fischer had not been able to prevent the couplers from wandering from layer to layer and mixing the dyes. Mannes and Godowsky concentrated on this problem after Dr. C. Kenneth Mees, head of the Kodak research labs in Rochester, New York, invited them to work with the Kodak staff in 1930. The outcome of their subsequent research (with a team of specialists that Mees put at their disposal) was Kodachrome, launched first in an amateur movie film version in 1935 and in 35mm rolls for still cameras the following year.

As a solution to the problem of wandering dye couplers, the Kodachrome process was rather cumbersome at first: the couplers were introduced only during processing, which involved 28 stages. However, Kodak soon found a way of including the dye couplers within the tripack itself. Similar methods had meanwhile been developed by the German company Agfa, whose secrets were made public at the end of World War II when the Allied forces took over the Agfa factory. By the mid-1950s, the Kodak and Agfa technologies were the basis of high-quality, easy-to-use color film available from a number of manufacturers.

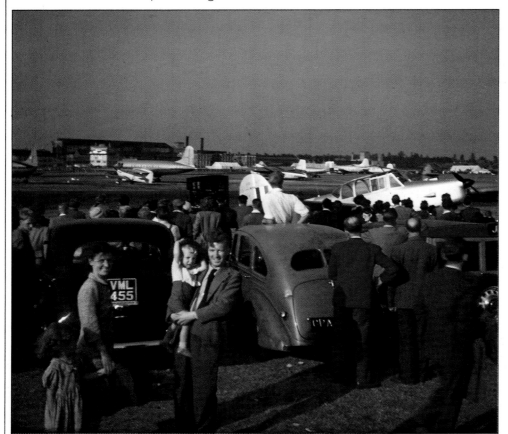

An air show (left), brimming with life and color, is the subject of a Kodachrome snapshot taken on a family outing in the 1950s by an English amateur photographer, Horace Dall.

American troops (opposite) raise the Stars and Stripes for the first time over the Army base on St. Lucia in October 1941. During the war years, supplies of Kodachrome were restricted to military uses.

The two musicians – Leopold Godowsky, Jr. (left) and Leopold Mannes – used their musical talents to good purpose while working in the Kodak laboratories. By whistling in the darkroom with perfect timing, they were able to monitor photographic processes without a luminous clock, which could have fogged their materials.

Slide mounts and film packs
The first Kodachrome films for still photography were returned in continuous film strips after processing by Kodak. But in 1938 a ready-mounting service was introduced, and the 2 × 2-inch cardboard mounts (bottom) were adopted as a universal pattern that is still in use today. Slide film packs have also changed little from their original design (below, left).

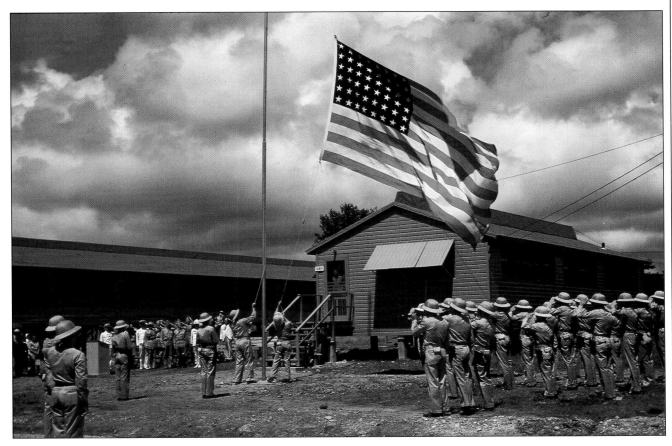

Color for convenience

The research that led to Kodak's first color print film also contributed to military surveillance photography during the Second World War. The armed forces appreciated the value of color photography for aerial reconnaissance, but needed a color film that could be processed in the field. This ruled out Kodachrome film, with its complex processing cycle. Kodak stepped up its research, and evolved a color negative process that was the basis of both Kodacolor print film, introduced to the American public in 1942, and Ektachrome slide film, which appeared a few years later. Kodacolor film was enormously popular and rapidly transformed the appearance of the family album, as shown below.

Kodacolor film had a number of unprecedented features. First, it incorporated minute oily globules in the emulsion layers that prevented the dyes from wandering from one layer to another. But even more remarkable was a processing method using a one-stage color development that yielded a negative in which the hues as well as the tones were reversed; from this negative an unlimited number of color prints could be made on paper.

After the war, significant improvements were made to color print film. One of the most notable of these, introduced in 1949, was the correction of color inaccuracies by means of an orange-colored mask built into the emulsion layers.

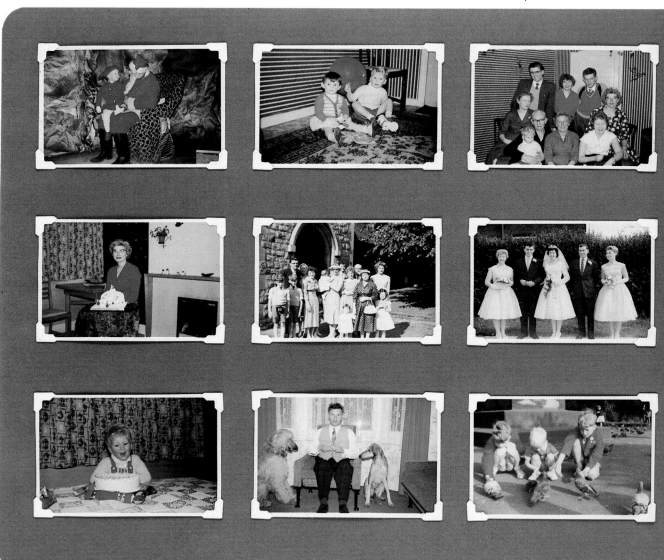

Color for all

Like Kodachrome film, Kodacolor print film was aimed exclusively at an amateur market. It was adopted enthusiastically, partly because no extra equipment was needed: photographers could use the same cameras that they had bought for black-and-white film (like the example at left, from the 1950s) and the same photo-albums. The colors of early prints – and particularly the reds – were more garish than they are today. Nevertheless, they were perfectly adequate for family snapshots of the kind shown on the album pages below.

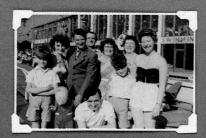

Instant color

By the early 1960s, enthusiasts were running more color film than black-and-white through their cameras. Color processing was complex but this was of no concern to the photographers, who mostly sent their films to laboratories for processing. With quality color pictures available to all, it must have seemed as if the technology of color photography had reached its limits. Then, in 1962, Dr. Edwin Herbert Land, President of the Polaroid Corporation of Cambridge, Massachusetts, announced to his shareholders a color version of the black-and-white instant picture process he had invented less than two decades earlier.

Polacolor film worked on a similar principle to the complex dye-transfer printing process, except that a full-color print was delivered straight from a Polaroid Land camera with a minimum of effort. The photographer simply pulled a tab on the end of the film, waited 50 seconds, then peeled off the backing paper to obtain the print. The film consisted of the three color-sensitive layers of regular color negative film and, beneath each layer, a ready-formed layer of the complementary color dye plus a spacing layer. Pulling the film tab squeezed the layers together, which released the developing chemicals. In exposed areas the developed particles blocked the dye transfer; but in unexposed areas the dyes moved to the printing paper to form a positive image.

Technological advances since 1962 have significantly improved the quality, simplified the operation and lowered the cost of instant color photography. Eastman Kodak Company introduced a line of instant color products in 1977, intended to provide low-cost high-quality images with a minimum of user involvement. More recently, Kodak Trimprint instant color film has been developed. This produces prints that can be separated from their image-forming backing layer after one hour to yield a photograph that closely resembles a conventional color print. The brilliant color rendition that characterizes this film is shown in the example on the opposite page, below.

The development of Polaroid
Dr. Edwin H. Land first demonstrated one-step photography in 1947. At a presentation to the Optical Society of America (left), he exposed a black-and-white negative in a view camera, then peeled the negative away from the positive to yield the finished image.

When Land adapted the instant print to color photography, he again based his invention on the "peel-apart" principle (shown in a later version below at left). However, with the SX-70 camera and film system, first exhibited in 1972, peeling off a backing layer was no longer necessary: the image developed before the photographer's eyes in just a few minutes. The photograph below shows Land demonstrating the SX-70 folding camera, whose electronic shutter and film-advance were powered by a wafer-thin battery built into the film pack.

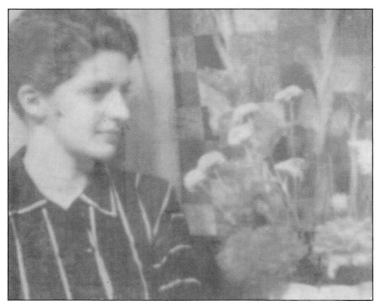

This early instant print has weak hues, and there are blotches and streaks caused by uneven development and dye transfer. Land created the prototype instant color print in 1955, but spent another seven years improving the process before introducing it to the public.

Keep-fit enthusiasts pose for a triple portrait (below). This manufacturer's demonstration print, shown here at an enlarged size, illustrates the vivid colors and accurate flesh tones that characterize Kodak's Trimprint instant color film.

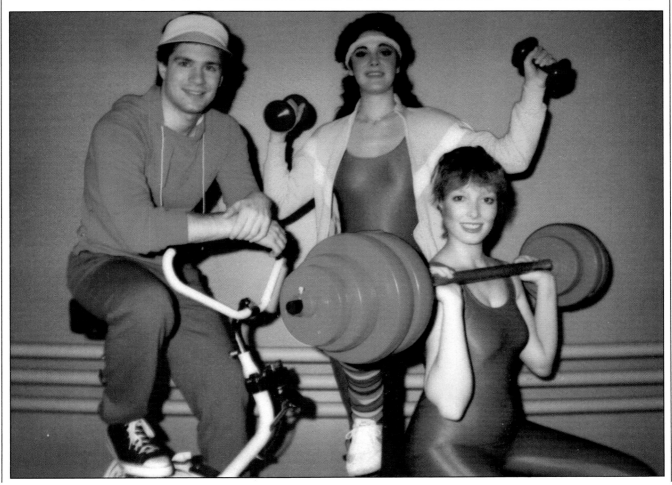

MASTERS
OF COLOR

The pioneers of color photography were delighted if they could reproduce the hues of a scene with tolerable accuracy. Their watchword was realism, their motive the thrill of pushing back the boundaries of science. However, with the technological breakthroughs of the 20th Century came photographers who paid attention to composition and even to the nuances of light and mood, as well as to color verisimilitude. Their pictures today often have a double fascination: they are pleasing, consummately artistic images as well as records of a lost era.

With the advent of the integral color tripack in the 1930s and the subsequent popularization of color photography, the true masters become harder to identify among the hundreds of professional and amateur photographers who stretched the medium to its limits of creative expression. However, there are some giants who tower above the rest: for example, English photographer Norman Parkinson, who took the dramatic picture at left.

This section contains a selection of photographers and schools of photography whose works can be considered milestones in the art of using color. Some of those represented were handicapped by the bulky cameras and imperfect color film that the technology of their day imposed upon them; others had the advantage of more sophisticated equipment and materials. But one thing they all share is a standard of excellence, particularly in the imaginative use of color, that gives them a place in the history of photography.

A display of hat fashions
was the purpose of this picture
taken on Kodachrome film
by Norman Parkinson in New
York City in 1949. Yet the
simple color accent, and the
dynamism of the models' poses,
give the image an esthetic
value beyond its documentary
interest or period charm.

Photos for the Czar

Images of Czarist Russia are rare and usually have a drab sepia tone that bears little resemblance to the diverse and colorful world that Tolstoy and Chekhov described. So it comes as a revelation to see photographs of the Russian empire in colors that seem as rich as the day they were taken.

We owe this glimpse of the past to Sergei Mikhailovich Prokudin-Gorskii, an ex-chemist who in 1909 persuaded Czar Nicholas II to commission a photographic survey of his vast domain, so that "people might better appreciate the heritage of their glorious motherland." The photographer's zeal for his task was matched by that of his benefactor, who provided a darkroom and living quarters on a train, as well as several boats. Over the next six years, Prokudin-Gorskii traveled widely, making a unique record of a society that was soon to disappear. He used a novel camera that made three consecutive exposures within three seconds, one each through a red, a blue and a green filter. With this, he documented not only the finery of Czarist officials but also humbler scenes of peasant life.

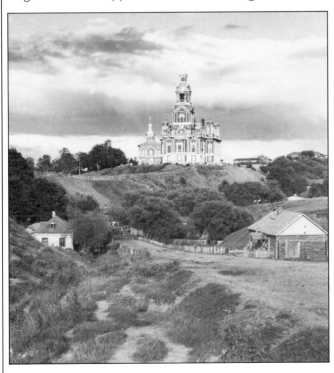

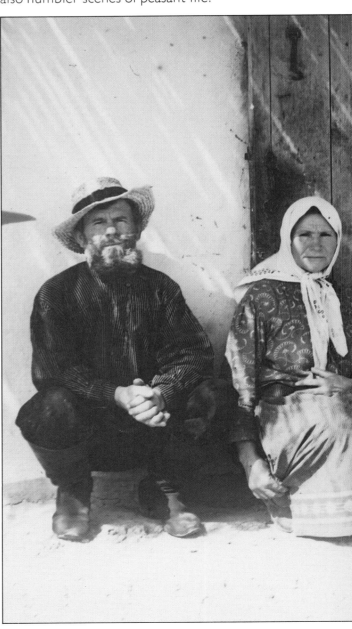

The Cathedral of St. Nicholas
in Mozhaisk rises magnificently above shacks and muddy roads. Prokudin-Gorskii's technique was best suited to static subjects such as this landscape; moving subjects appeared fringed with color.

The range of subjects at which this photographer directed his lens was extraordinarily broad. His achievement seems all the more remarkable in view of the state of color technology at the time. While Prokudin-Gorskii was making spontaneous-looking images of the Russian people and landscapes, his contemporaries in the West – using similar cameras – usually confined themselves to sterile studio views. Little wonder, then, that when Prokudin-Gorskii took a magic lantern show of his work to Paris it drew capacity audiences.

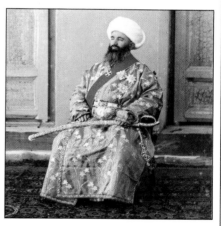

The Minister of Internal Affairs *in Bukhara (above) sits proudly in his turquoise uniform for a three-color portrait by Prokudin-Gorskii.*

A peasant family *in the Urals poses in the sun. Even in such bright conditions the subjects had to keep still for several seconds while Prokudin-Gorskii made three exposures.*

41

Portraits in muted colors

When the Lumière brothers introduced the Autochrome process to the world early in 1907, two of America's greatest photographers, Alfred Stieglitz and Edward Steichen, were in Paris to see the new plates on view at the Photo Club. They were delighted that an improved color process had at last been found. Stieglitz felt that the color inaccuracies of the medium were only a minor drawback, which could in fact be exploited creatively. "The rendering of pure white seems impossible," he said. "Artisti-cally, this is not a fault, and can be made use of." However, the fact that Autochrome faded with time was unacceptable to Stieglitz, so he at once took some plates to a color scientist in Munich and the two men began a series of experiments to make the plates more permanent by treating them with a var-nish. Meanwhile, in Paris, Steichen explored ways of adjusting the quality and tones of the plates to increase their artistic impact.

These two photographers were leaders of an

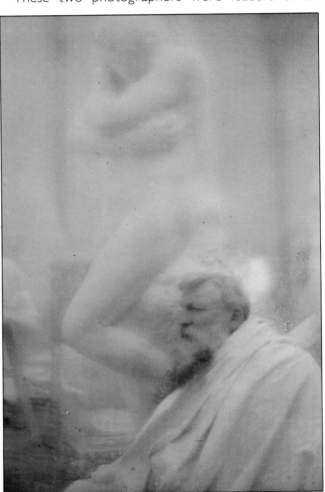

The sculptor Auguste Rodin (above) stands in front of his own work "Eve" in one of Steichen's most subtle and evocative Autochrome portraits.

Edward Steichen: a self-portrait

Gertrude Käsebier (left), an American photographer, poses in an Autochrome taken by Steichen in 1907. Steichen had obtained a supply of plates before they became widely available.

American movement called the Photo-Secession, whose aim was not simply to take photographs but to create works of art. To this end, some Photo-Secessionists working in black-and-white had enhanced photographs with brushes, pencils and etching tools. Not surprisingly, Autochrome plates caught on in this circle: their soft, romanticizing effect placed the subjects at a poetic distance from reality. The portraits made by Stieglitz and Steichen, exemplified here, had a quality all their own – a gentle naturalism quite unlike anything done by these two innovators before or after.

However, within two years, the Photo-Secessionists had turned their backs on the Autochrome process because it did not allow them enough scope to manipulate the image artistically. The English art critic Dixon Scott expressed their frustration in 1908: Autochrome plates, he said, were "a cold bath" – a worthy but unwelcoming medium, ultimately unfriendly to the romantic spirit.

Alfred Stieglitz: an Autochrome by Steichen

A lady in a plumed hat (above) stares penetratingly toward the camera. Stieglitz, who took this portrait, promoted the idea that a simple unmanipulated photograph could be a profound means of artistic expression.

A portrait of two girls (left) casually posed on a lawn shows Stieglitz' style at its most informal. The girl sitting at left in the image is Stieglitz' daughter, Kitty.

43

The Photo-Impressionists

A landscape on a still day was a more accessible theme for the Photo-Impressionists than were moving subjects. This view is by Personnaz, whose landscape Autochrome plates are among the most evocative ever taken.

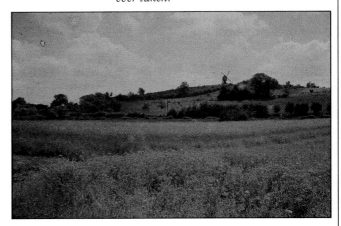

The soft, subdued colors and grainy appearance of photographs taken by the Autochrome process are reminiscent of late 19th Century French Impressionist painting. And because Autochrome images are made up of dots of color, they also have affinities with the Pointillist technique of painting developed by Georges Seurat in the 1880s, which involved the application of tiny dots of pure color to the canvas. Such similarities were recognized soon after Autochrome plates became generally available in 1907, and they explain why the process caught on rapidly in artistic circles. Photographers like Antonin Personnaz chose their subject matter from the themes that had attracted the Impressionists. For example, the poppy-strewn meadow at right recalls the idyllic French landscapes of Claude Monet, while the study at the bottom of this page consciously evokes a painting by Edouard Manet. Even city views, such as the one on the opposite page above, often had a nostalgic, painterly feel about them.

Because they were restricted to small, rather dim transparencies, the Photo-Impressionists could never hope to match the shimmering colors of the painters they imitated. However, the Autochromes of Jacques-Henri Lartigue achieved a lasting reputation, precisely because they broke free of the influence of fine art, even though Lartigue was himself a painter. In photography he valued color above all for its realism, and for this reason he took all his Autochrome plates as stereo pairs, for a three-dimensional effect. Although the plates required human subjects to hold a pose for several seconds, Lartigue used them to create images of freshness and spontaneity, like the one opposite, below.

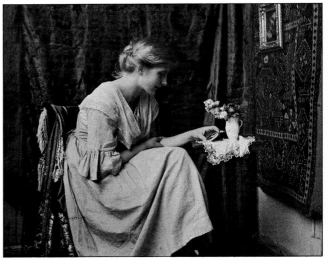

A woman muses over her pendant (above) in a 1921 Autochrome plate by Carlo Zaar, an Austrian professor of geology. For an artificially lit portrait such as this, an exposure of at least 10 seconds would have been required, yet Zaar has succeeded in getting his sitter to maintain a natural-looking pose.

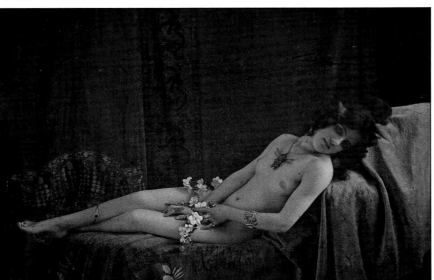

A studio nude (left), taken by Paul Bergon around 1910, recalls Manet's famous painting Olympia in the borrowed pose and use of flowers and jewelry as accoutrements that provocatively enhance the model's nudity.

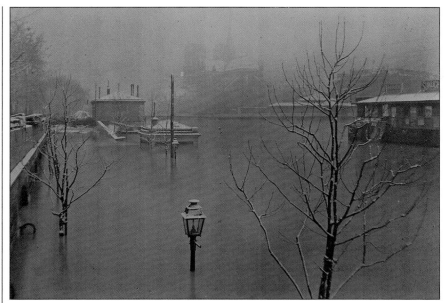

Paris flooded and powdered with snow (left) is the subject of a beautifully muted Autochrome plate by a French photographer named Gimbel. The graininess of the plate is perfectly appropriate to this subject: it emphasizes the impression of wintry mist.

Lartigue, flanked by pairs of friends (below), poses for an informal Autochrome portrait taken using his camera's self-timer in 1913.

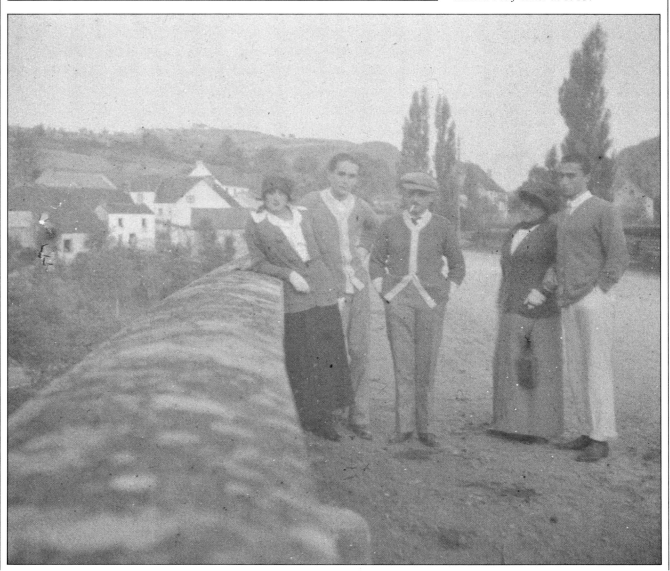

Color in vogue

In the 1920s and 1930s, color photographs began to appear in the top fashion magazines. The trend toward full-color fashion shots really took off with the partnership of photographer Anton Bruehl and color technician Fernand Bourges. Bourges' skill with the three-color process was the key to their success. He insisted on the best-quality dyes and made, for each picture, three different transparencies for printers to work from. The resulting colors were saturated and accurately rendered, as shown by the ballerina portrait opposite. *Vogue* published the partnership's first color picture in 1932, and during the next two years the magazine ran 195 pages of Bruehl-and-Bourges color photographs.

Meanwhile, other photographers were developing their own inimitable styles. For example, the color fashion photographs of Horst P. Horst were characterized by a richly sensuous idiom illustrated by the *Vogue* cover below.

Color gave magazine readers an entire fashion look to emulate, showing not only the cut, texture and color of a dress, but also the model's hair color and the exact shade of her lipstick. This total look, created by color, has been the hallmark of fashion photography ever since.

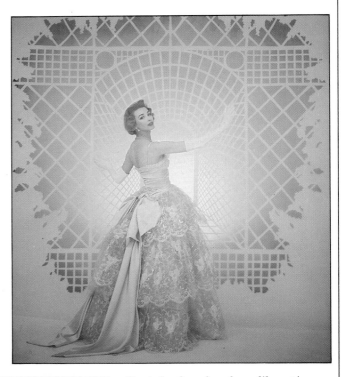

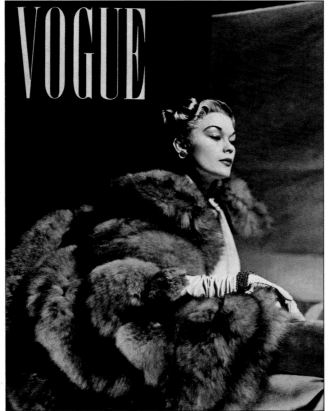

Pastel colors in a dreamlike setting (above) show off the fine lace and silk of an evening gown. The photographer was Cecil Beaton; perhaps because he was also a stage and costume designer, his fashion shots often have a distinctly theatrical quality, with a free, sometimes fantastic, play of color.

The model in the blue fox cape appeared in the November 1937 cover of the English Vogue. *The air of sumptuousness, the rich, dark colors and the dramatic lighting are all typical of a Horst image.*

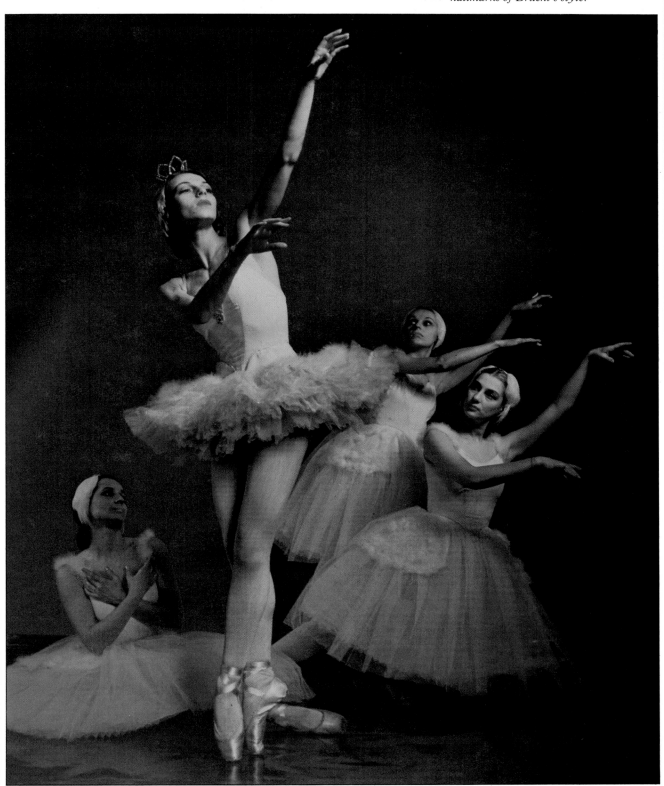

Four ballerinas form a dynamic grouping in a studio portrait taken by Anton Bruehl in the mid-1930s and printed by Fernand Bourges. Dramatic lighting and rich, saturated colors are hallmarks of Bruehl's style.

Elegant still-lifes

In 1929 the American photographer Paul Outerbridge, already admired for his original work in black-and-white, resolved to create "the best color shots made by anybody, anywhere." To this end, he adopted the luxurious and incredibly difficult carbro process, of which he became a complete master. For each print, he made three separate exposures through red, green and blue filters. Then he made a black-and-white print from each negative and transferred the images from these prints onto tissues that had been coated in gelatin pigmented with cyan, magenta and yellow dyes; these tissues were less than one ten-thousandth of an inch thick. Finally, and most arduous of all, Outerbridge transferred the three resulting color images in perfect register onto a special "transfer paper."

This process, used for two of the three prints from the mid-1930s shown on these two pages, could take eight or nine hours, and each print cost at least $150 to make, at a time when the economic depression was at its worst. However, the rewards for all this labor and expense were some of the most delicately hued color prints ever made, with an image quality that is difficult to match even today.

Outerbridge was more, though, than just a virtuoso technician. His elegant still-lifes, and later his nude studies, put him in the forefront of the small group of innovators whose work broke down the barriers between photography and fine art. He absorbed two movements that had revolutionized Western painting – cubism and surrealism – and developed them in a uniquely photographic way to create bizarrely beautiful images out of simple everyday elements.

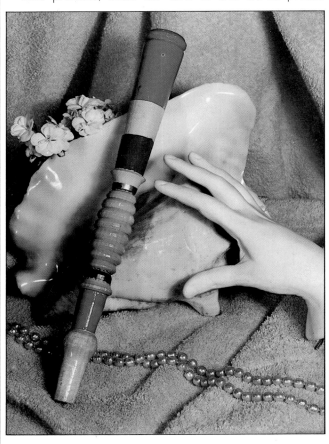

A party horn, a shell, a posy, a pearl necklace and a mannequin's hand make an intriguing combination in a still-life close-up. The subtle tones of the shell and the brilliant reds in the image are even more impressive in the original print, made by the dye transfer process.

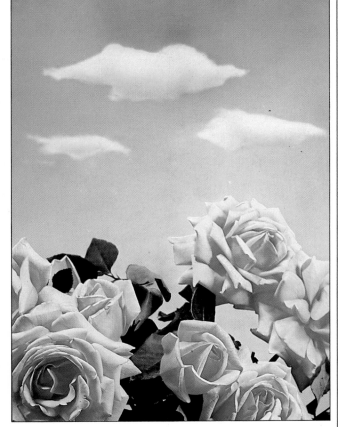

Roses and clouds combine, with simple but surreal effect, in a beautifully composed print from 1937. The superb image quality of the carbro process has given the roses a sensuous, almost tactile quality that is typical of Outerbridge's work in color.

The stark geometry of a sphere, a cone and a cube contrast with the richly textured surface of a seashell in a still-life carbro print inspired by cubism, an art movement whose exponents portrayed the world in geometrical shapes.

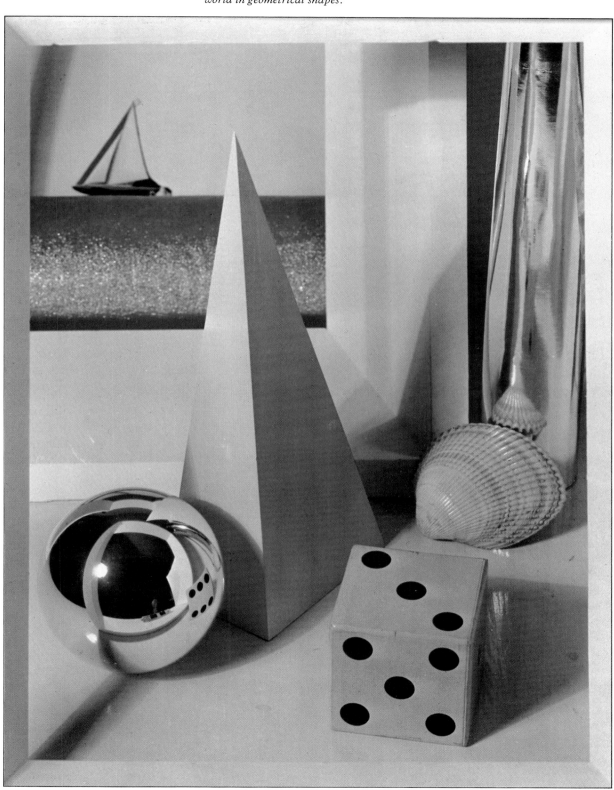

The subtle hues of nature

In 1979 New York City's Metropolitan Museum of Art mounted its first one-man exhibition of color photographs, "Intimate Landscapes," by American photographer Eliot Porter. The show somewhat belatedly acknowledged Porter's major achievement in the late 1950s and early 60s, in realizing the possibilities of color photography as a fine-art medium.

Porter's landscapes, all infused with his profound love of the natural world, thoroughly explore nuances of hue and detail that a more casual observer might never notice. Although sometimes inspired by spectacular effects of light and atmosphere, as in the picture at far right, below, most of Porter's work draws attention to dramas on a humbler scale – for example, the range of colors in a scattering of fallen leaves or in a rock face. To such scenes he brings a meticulous, almost microscopic observation that perhaps owes something to his training in biochemistry and bacteriology. And to ensure an accuracy of reproduction to match the scientific yet passionate accuracy of his vision, Porter makes his own prints using the painstaking, high-fidelity dye transfer process, which involves transferring dyes from three separately prepared images.

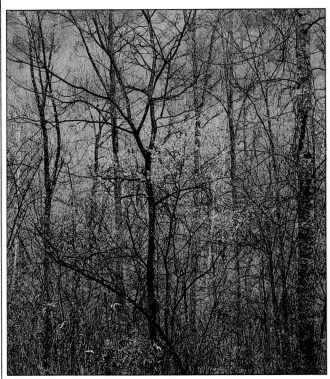

*A **redbud tree** in flower adds color to a Kentucky woodland. A simple eye-level view re-created Porter's pleasure in this muted springtime scene.*

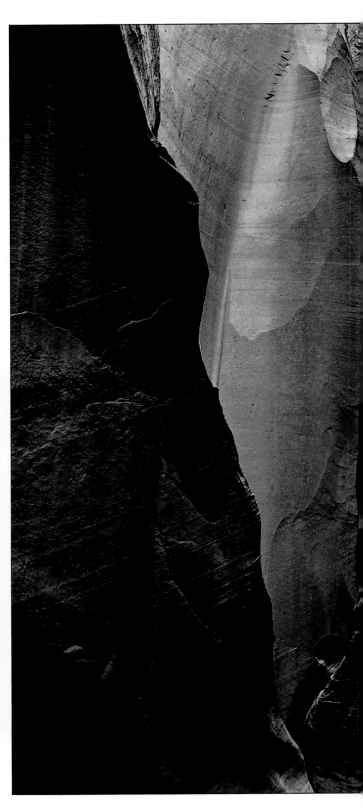

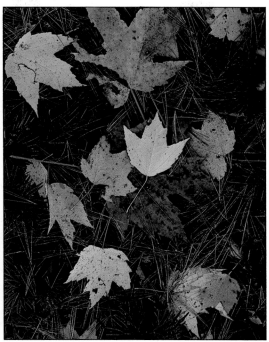

Maple leaves (below) strewn with pine needles suggest the ripeness of a New England fall. A close viewpoint vertically downward emphasized the rich detail, the graphic shapes and the range of delicate hues.

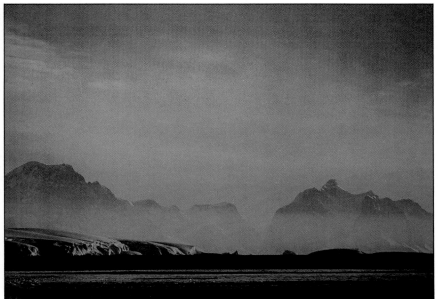

Sunset (above) envelopes an Antarctic scene in a golden haze. Porter exercised extreme care in printing to avoid dust specks on the pale, subtle colors.

A cleft in a Utah canyon (left) reveals rich earth tones. Porter framed close to confuse scale and create an abstract feel.

51

Exotic color

In the mood of optimism that followed World War II, people were hungry for new sights and sensations. Although military personnel had gone half way around the world, travel in peacetime was neither cheap nor easy. Millions looked to picture magazines like *National Geographic, Life* and *Look* for a taste of the distant and exotic. Their photographers became the nation's roving eyes.

The publishers of those magazines had seized on color reproduction as soon as it became practicable, using it to add excitement and immediacy to their journals. *National Geographic* had used color plates as early as 1916. However, it was in the 1950s that

progress in color printing – and in photography itself – led to a mushrooming in the use of editorial color. A particularly important development was 35mm Kodachrome. It enabled photographers to use light, handheld cameras and a variety of easily changeable lenses, instead of cumbersome large-format plate cameras.

To supply a lavish diet of color pictures, the magazines hired the very best photographers and backed them up with huge budgets. If a story called for an aerial view, a plane or helicopter was provided. If the photographer needed to use 500 rolls of color film, the magazine would authorize the expense for

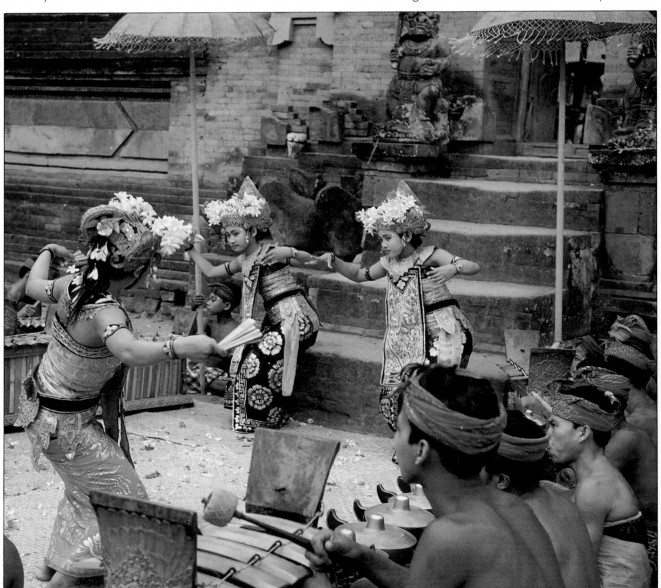

the sake of the one perfectly timed image or the one absolutely correct exposure in the right weather.

The photographers repaid their employers with pictures of astonishing range and beauty. They did not confine themselves to distant locations, but also trained their lenses on wonders nearer home. By the 1960s a flood of color pictures began to appear on television as well as in a multitude of journals. But the great photo magazines had shown a whole generation of amateur photographers the potential of color film: its ability to delight the eye and to create unique pictorial effects, as well as to record the world's colors in all their vividness.

Dancers in Bali *(left)*
provided an exotic image in
National Geographic *in 1961,*
before travel to the Far East
became commonplace.

The luxury of a vacation *in*
the tropics was evoked for
National Geographic *readers*
in 1940 by the view below,
illustrating an article on
the Virgin Islands.

A hummingbird *(right)*
sips nectar from a banana
blossom, its beauty captured
by Life's *John Dominis.*
The image appeared in a
story on Dominica in 1966.

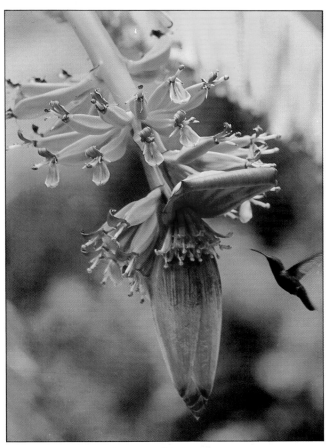

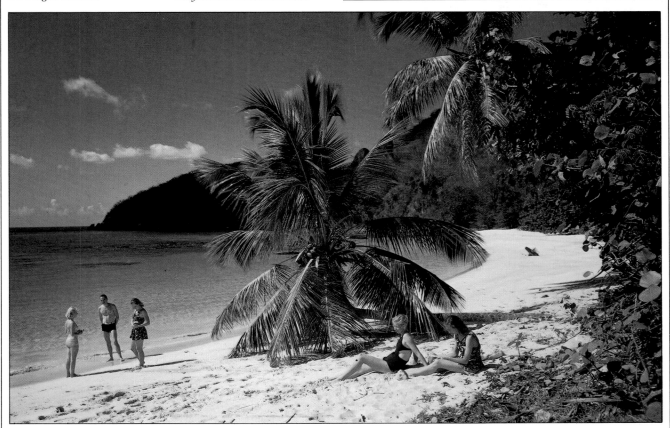

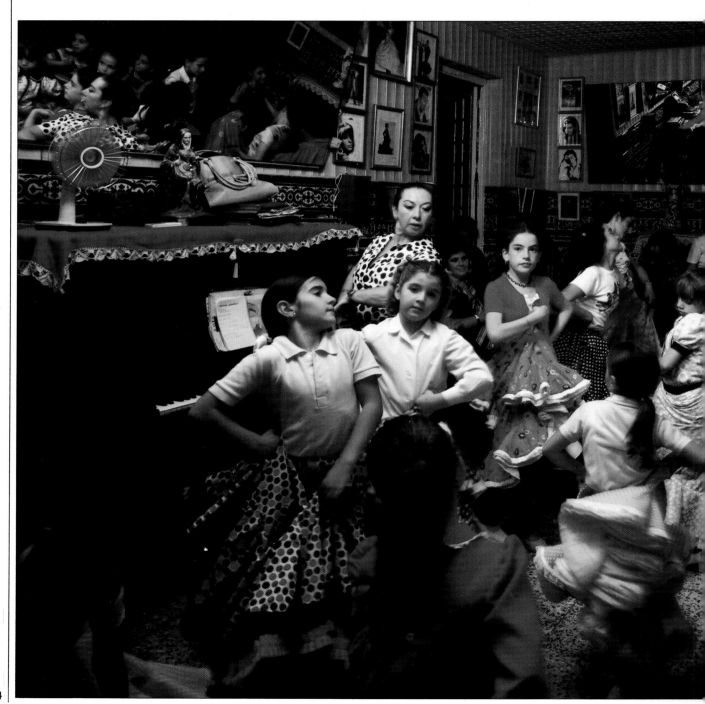

CONTROLLING COLOR

Every photographer knows the importance of carefulness in judging composition, focus and exposure setting to obtain the desired image. But with color film these and other photographic techniques can change not only the basic image but also the appearance of the colors themselves. Indeed, creative decisions about color begin at the very earliest stage of photography, when you choose which type of film to buy.

To extend your capability of reproducing the colors of a scene accurately, the first step is understanding the basic principles of color vision and subtractive color, and the characteristics of different film types. Then you can progress to a repertoire of techniques that give you significant control over color in a range of outdoor and indoor lighting conditions. By familiarizing yourself with fine-tuning methods available to any photographer, you can triumph over difficult situations, as in the picture at left, or give a creative lift to otherwise mediocre images.

In these days of advanced photographic technology, the very ease of taking color pictures can lead to hastily conceived, disappointing images. But by learning to manipulate color, you can derive maximum advantage from modern equipment and materials and take photographs that will give you lasting pleasure.

A Spanish dance class throbs with movement and color. To record the rich hues accurately without loss of atmosphere, the photographer supplemented the room's tungsten lighting with flash. He used a pale yellow 81A filter and exposed for 1 second, thereby adding just enough warmth to the scene to counteract the flash's tendency to coolness.

How the eye sees color

Photographs sometimes look so lifelike that it is tempting to think that film "sees" the same colors our eyes do. However, while film can mimic the colors of reality very well under the right conditions, there are profound differences between the workings of eye and film. An understanding of how we see color can help you anticipate when the camera will distort the hues of a scene.

An example of this distortion occurs in dim light. We respond to color by means of cone-shaped receptor cells at the back of the eye, as shown below. These cells function efficiently only in bright light; in dim conditions, other cells – the rods – take over. These are more sensitive than the cones, but they are color-blind. As a result, in darkness we see primarily in black and white. Film, on the other hand, does not lose its color sensitivity in the same way; so if you take pictures by moonlight or in twilight, the results will look more colorful than they did in the original scene. The pictures opposite at right show this effect in simulated form.

Despite the differences between them, film and the eye do share a three-part response to color. Just as film has three layers, sensitive to the three

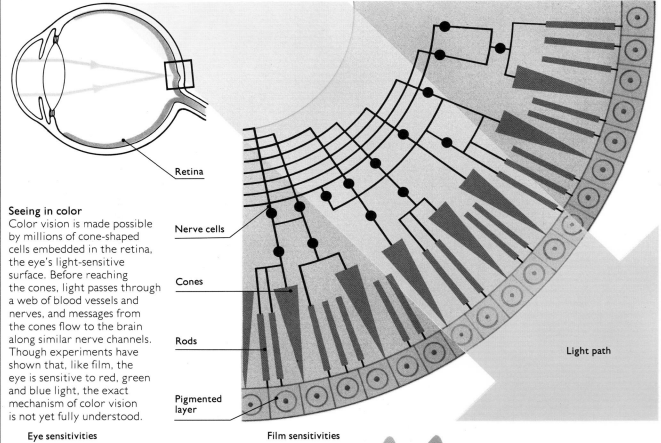

Retina

Nerve cells

Cones

Rods

Pigmented layer

Light path

Seeing in color
Color vision is made possible by millions of cone-shaped cells embedded in the retina, the eye's light-sensitive surface. Before reaching the cones, light passes through a web of blood vessels and nerves, and messages from the cones flow to the brain along similar nerve channels. Though experiments have shown that, like film, the eye is sensitive to red, green and blue light, the exact mechanism of color vision is not yet fully understood.

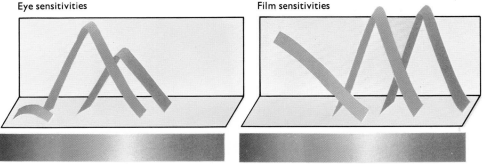

Eye sensitivities

Film sensitivities

Color sensitivity
The color responses of eye and film differ significantly, as these graphs show. Each layer of film responds mainly to one primary color – red, blue or green (near left). However the eye's response (far left) is more complex, showing more sensitivity to green than to red and blue.

primary colors – red, green and blue – our eyes have three different types of light-sensitive cells, which together enable us to see the full spectrum. However, the sensitivities of eye and film do not coincide perfectly, as the graphs here show. As a result, some colors appear brighter to the eye than they do in photographs. For example, yellow light stimulates all three types of color cells in the eye, so yellow seems to be a very bright color. But film is designed so that yellow light exposes only two layers, hence brilliant yellows often appear dimmer on film than they do to the eye, as shown below.

Eyesight versus film

Brilliant yellow stimulates all three types of cone cells in the eye, so the yellow seems very bright in the simulated view at top. But only two of film's three layers are exposed by yellow light, so the intensity of yellow in the photograph (bottom) does not match what is seen by the eye.

Color vision fades in dim light, and the ability to see red vanishes first. Because the sensitivity of film changes much less in dim light, photographs taken at dusk appear redder, and generally more colorful, than a scene as we recall seeing it, as suggested by the comparison above.

Color by subtraction

Prints and slides are capable of representing a vast range of colors, from delicate pastel tints to vivid primaries. So it may seem surprising that the colors in any color photograph are made up from just three dyes – yellow, magenta (purplish-red) and cyan (blue-green) – which are collectively called the subtractive primaries.

Why are these colors used to make photographs, when the additive primaries – red, green and blue – would seem a more obvious choice? The diagrams below show the reason: red, green and blue dyes transmit or reflect only one-third of the spectrum and absorb the other two-thirds. Mixing two dyes or overlaying two filters in the additive primary colors yields a muddy black or a dull brown. On the other hand, yellow, magenta and cyan each absorb one of the additive primaries, and transmit or reflect *two*-thirds of the spectrum. This means that when two of the subtractive primaries are mixed together, the result is not a dull earth color but a third bright hue.

Combining two subtractive primaries of equal strength yields one of the additive primaries. For example, a deep yellow filter and a deep magenta filter will produce a saturated red, as shown by the example at near right. Combining pale colors in uneven proportions produces subtle tints of an intermediate hue – as at far right – rather than pure primary colors.

In color photographs, the yellow, magenta and cyan dyes are contained in three separate emulsion layers, which together make up a "tripack." The emulsion layers of transparencies, coated on a clear plastic base, reveal the colors by transmitted light directly after processing. With prints, however, the true colors appear by light reflected from the white paper on which the same three emulsion layers are coated. Whichever method is used, the images in each layer are similar, and resemble those shown on the opposite page, below.

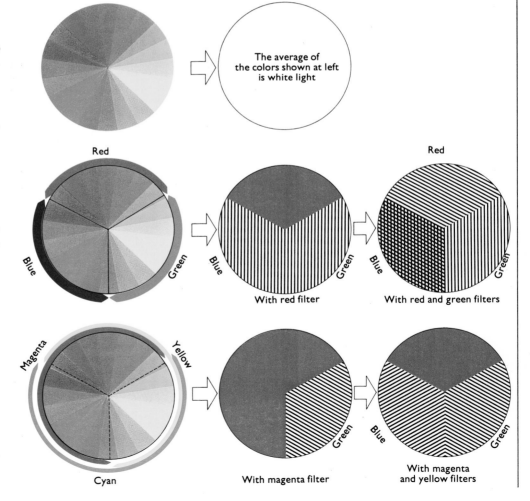

White light
White light is a mixture of all the colors of the spectrum, ranging from deep red, through green and blue, to violet. Here the colors are arranged in a circle on a color wheel. Combining the colors on the wheel in equal quantities would yield white.

The average of the colors shown at left is white light

The additive principle
The additive primaries each make up one-third of the spectrum; a filter in one additive primary color will absorb two-thirds of the colors on the wheel (center). Overlaying two additive primary filters blocks out all the colors (far right).

Red

Blue

Green

With red filter

Red

Blue

Green

With red and green filters

The subtractive principle
The subtractive primaries each cover two-thirds of the spectrum. A magenta filter cuts out only the remaining third, green (center). Since neither magenta nor yellow cuts out red light, mixing these two colors creates red, as at far right.

Magenta

Yellow

Cyan

With magenta filter

Green

With magenta and yellow filters

Blue

Green

The color palette
Mixing colors in different proportions produce virtually any hue. Combining saturated primary hues, as at far left, yields strong colors, but when only pale shades of the subtractive primaries are used (near left), very subtle tints appear. Mixing all three subtractive primary hues produces earth colors.

Color from film
Colors in photographs are built up by dyes in the three emulsion layers. Here, images in the cyan and magenta layers create the blue of the sky. Yellow and cyan images combine to form the green of the leaves, and magenta and yellow together make the red of the shutters. Black shadows appear on all film layers, and the white of the wall results from an absence of dye in any layer.

Yellow

Magenta

Cyan

Film for color prints

The basic chemical principles of color print film are easy to grasp. The film itself, like all color films, has three main emulsion layers, sensitive to red, green and blue light, respectively. The colors, however, appear only at the processing stage, as shown in the sequence opposite, above. In darkroom conditions, a latent image in each of the emulsion layers is developed into a black-and-white negative. This process releases chemical byproducts that react with "color couplers" included in the emulsion layers during manufacture, thus stimulating the formation of color dyes in each layer: yellow in the blue-sensitive layer, magenta in the green-sensitive layer and cyan in the red-sensitive layer. Because the byproducts are released only in the developed areas of the film, dye formation follows the pattern in the black-and-white negative in each layer; the dye images thus duplicate the negative images, which are formed by black metallic silver. However, before the composite effect of the dye images can be seen, the black silver must be bleached out.

The result of processing is a negative dye image in which the colors, as well as the light and dark tones, are reversed. When white light passes through this negative, the layers of subtractive primaries absorb the original hues of the image and transmit their complementaries. For example, where the original scene is red, the cyan (red-absorbing) dye is formed. However, when you examine a color negative, the reversal of colors is disguised by a distinctive amber cast caused by dye masks incorporated in the film to compensate for deficiencies in the image-forming dyes. This cast is corrected during printing, which restores the original colors of the scene by exposing the color negative image on a three-layered emulsion similar to that of the film.

An advantage of color negative film is its tolerance of wide variations in exposure setting, as demonstrated opposite, below. Large processing labs use printmaking machines that scan the negative and to some extent compensate automatically for over- and underexposure. However, these machines can be deceived by large areas of color, as shown above at right. To obtain accurate colors in subjects dominated by a single color, you may need to pay more for individual attention at the laboratory or print your pictures at home.

Errors in color printing
The print at the top of this page was made from a correctly exposed negative. But the water caused the photolab's printing machine to compensate for the "excess" blue, causing a yellowish image. Careful home printing (right) produced a more acceptable result.

From latent image to negative

Developing
Developer acting on the exposed film in the first stage of processing produces a black silver negative image in each of the three emulsion layers. At the same time, coupled dyes form in each layer. The combined effect is shown in simulated form above.

Bleaching
Bleaching changes the unwanted black silver images to soluble compounds in each emulsion layer. The orange cast occurs because the dye couplers in the green- and red-sensitive layers are given a yellowish and pink tinge, respectively, to remove color imbalances.

Fixing
Fixing in a fixer bath removes the silver compound left over from bleaching and results in a stable three-colored dye image – the final color negative from which the print is then made. Normally, the bleach and fix stages are combined in a "blix."

The exposure latitude of color print film
The color prints shown here were processed at a quick-service lab from 12 negatives of a single scene. The pictures were taken in the same light on Kodacolor 100 film at f/2.8 at varying shutter speeds. The lab compensated for as much as six stops overexposure but it is not possible to correct for underexposure nearly as well.

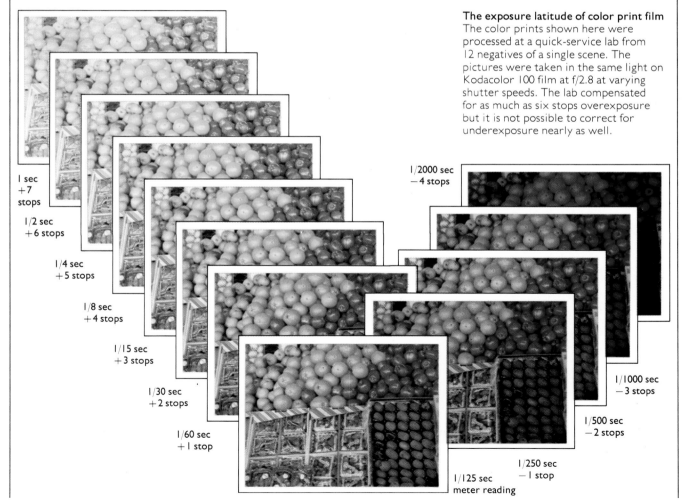

1 sec
+7 stops

1/2 sec
+6 stops

1/4 sec
+5 stops

1/8 sec
+4 stops

1/15 sec
+3 stops

1/30 sec
+2 stops

1/60 sec
+1 stop

1/125 sec
meter reading

1/250 sec
−1 stop

1/500 sec
−2 stops

1/1000 sec
−3 stops

1/2000 sec
−4 stops

Film for slides

Color slides produce a positive image directly on the film. Because there is no printing stage at which exposure faults can be corrected, color slide film has a narrower exposure tolerance than color print film and thus requires more care with exposure as shown opposite, below. But there is a great gain in color saturation, and because you view the picture by transmitted light instead of reflected light, the brightness range is closer to what the eye sees.

With the notable exception of Kodachrome film, most slide films work much as color print films do. However, two development stages are needed to create the positive image. The second of these reverses the tones of the negative image, which is why these films are known as "reversal" films.

During first development, black-and-white developer turns the exposed silver halide crystals in the emulsion into a black silver negative, but the color couplers as yet remain inactive. Then, the unexposed silver halides are reduced to silver ("fogged"), either by exposure to white light or, more usually, with chemicals. Fogging renders the unexposed silver halide crystals developable. As these crystals are developed in the second (color) developer, color couplers are stimulated, and dyes form around a second, positive black silver image. In the final positive image, the dye produced in each layer is the complement of the color of the light that was originally recorded there: thus, yellow dye is formed in the blue-sensitive layer, cyan in the red-sensitive layer and magenta in the green-sensitive layer. A blue subject, for example, would record in the magenta and cyan layers, which subtract blue's complementary – yellow – from white light passing through the slide.

With Kodachrome film, the major difference is that the color couplers are not included in the emulsion layers during manufacture. Instead three different color developers are necessary to form the dye in each layer during processing, which must be precisely controlled and is extremely complex. Kodachrome films must normally be returned to Kodak for processing. But the film more than compensates for this minor inconvenience with its excellent stability and extreme sharpness, which make it a favorite with many professionals.

Kodak's daylight films
Kodachrome film is available in two film speeds, ISO 25 and 64. Both produce very bright, saturated hues, especially reds, and excellent skin tones. Bluish results under an overcast sky can be corrected using a No. 81A or No. 81B filter. The film's exposure latitude is half a stop either way. Kodachrome 25 film, used for the carnival scene at right, is one of the sharpest and least grainy of all slide films.

Kodachrome's slow speed generally makes it unsuitable for low light conditions. Instead, use a faster film such as Ektachrome, which is available in speeds of ISO 200 and 400 as well as ISO 64. Medium-speed or fast slide films produce natural colors, but perform best with a No. 81A filter (or a No. 81B in cloudy conditions). They have a wider exposure latitude than Kodachrome (but not so wide as that of color negative film) and can be processed by many labs or in a home darkroom.

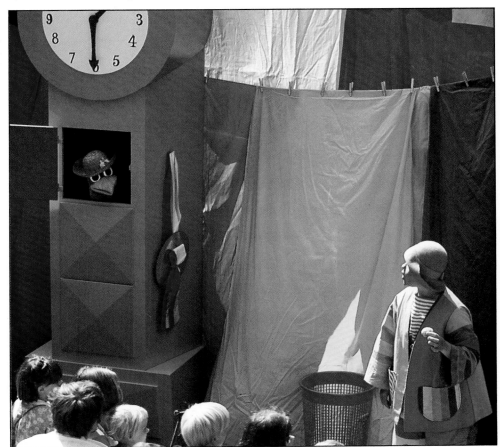

From latent image to slide

 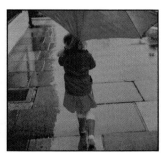

First development
A developer turns exposed silver halides into a black silver negative image in each emulsion layer, as simulated above. Fogging then makes all unexposed silver halides developable: where the blue coat was recorded, the unused green and red layer halides can be developed.

Color development
A color developer produces a black silver image in areas unaffected by first development, while the color couplers stimulate dye formation. Thus, the blue jacket forms a positive image in black silver and in magenta and cyan dyes.

Bleach and fixer
A combined bleach and fixer solution dissolves away the black silver leaving a milky image, which clears on drying.

Final image
When the slide is viewed in transmitted white light, the magenta and cyan dye layers subtract greens and reds, so that the jacket appears blue, as it was in the original scene.

The exposure latitude of slide film
Shown here are seven views of the same scene taken in the same light on Ektachrome 200 film at f/16 at varying shutter speeds. The test revealed an exposure latitude of one stop over, but underexposure by one stop produced an unacceptably dark result. The exposure latitude of films with speeds of 400 is usually slightly greater.

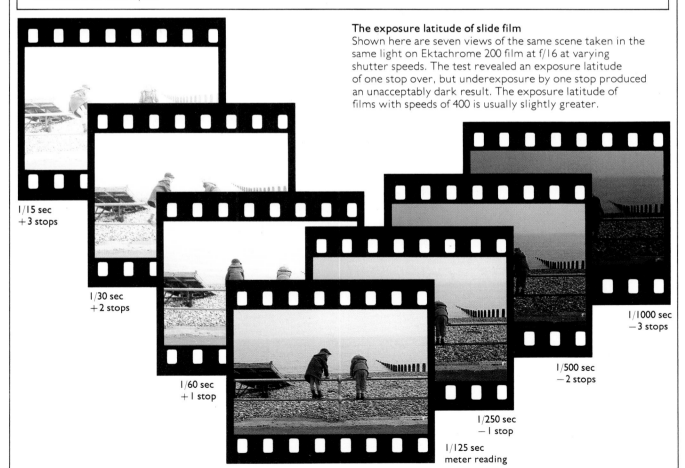

1/15 sec
+3 stops

1/30 sec
+2 stops

1/60 sec
+1 stop

1/125 sec
meter reading

1/250 sec
−1 stop

1/500 sec
−2 stops

1/1000 sec
−3 stops

Filtering natural light

Color film often responds to slight changes in the quality of light that the eye does not notice. A white wall may look equally white on a sunny or a cloudy day, but the photographic result may reveal otherwise. This is because light varies considerably in color temperature, as the diagram at near right shows. Color temperature, measured in kelvins (k), rises as the proportion of blue wavelengths in the light increases. Thus, the reddish glow of sunrise may be about 3,000k; while the illumination in a shady spot on a sunny day is provided solely by deep blue light from the sky, and the color temperature may be as high as 16,000k.

Both color print and daylight-balanced color slide film give reasonable color rendition in a broad range of natural lighting situations, and printing can correct all but extreme color faults on print film. However, daylight color slide film is balanced for 5,500k – the color temperature of midday sunlight or flash light. Light of any other color will produce a cast: bluish if the color temperature is above 5,500k, reddish if below.

Around the center of the temperature scale, color casts may be imperceptible. But toward either extreme, the cast may be undesirably intense and you may want to correct it with a filter. The most commonly used filter system is the series of Kodak Wratten conversion and light-balancing filters. Conversion filters are strong amber (85 series) or strong blue (80 series); they adapt daylight for tungsten film and vice versa. The light-balancing filters are much paler. The No. 81 yellow series warms up the light, that is, it lowers the color temperature; for example, a No. 81C or 81EF filter is useful if your subject is in the shade on a sunny day. The No. 82 blue series cools down the light or raises the temperature; these filters will prevent an orange cast early or late in the day.

The hues of daylight
The chart at right shows a color temperature scale for different natural light conditions; alongside are the appropriate filters needed to restore color balance when the temperature is either too blue or too red for satisfactory results on daylight-balanced film.

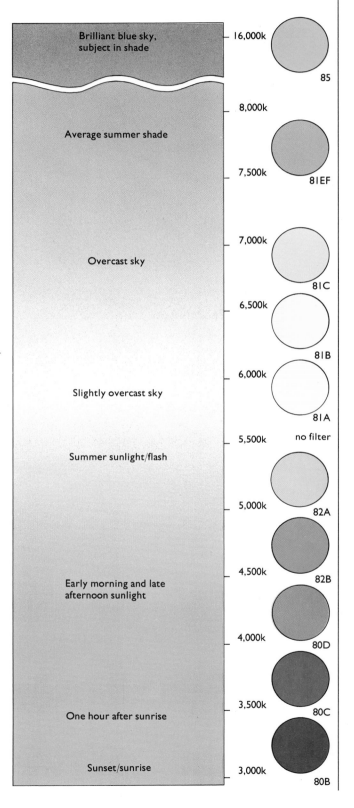

Brilliant blue sky, subject in shade — 16,000k — 85

Average summer shade — 8,000k / 7,500k — 81EF

Overcast sky — 7,000k — 81C

6,500k — 81B

Slightly overcast sky — 6,000k — 81A

Summer sunlight/flash — 5,500k — no filter

5,000k — 82A

Early morning and late afternoon sunlight — 4,500k — 82B

4,000k — 80D

One hour after sunrise — 3,500k — 80C

Sunset/sunrise — 3,000k — 80B

Daylight film, overcast sky
The picture below was taken when the sky was quite heavily overcast. To correct the cold blue cast produced by light of a high color temperature, the photographer used a No. 81C filter (right).

81C

Daylight film, midday sun
The picture at right was taken at about noon on a sunny day. In these conditions, the color temperature of the light was perfectly matched to daylight-balanced film, so no filter was needed.

no filter

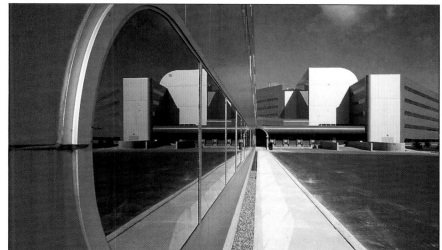

Daylight film, afternoon sun
The picture below was taken on daylight-balanced film without a filter in the late afternoon. A No. 80D filter corrected the orange cast to produce a midday effect (right).

80D

Filtering artificial light

Achieving good color rendition under artificial light can be difficult, not only because of the different types of lighting and their varying color temperatures, but also because scenes are often lit by two or more kinds of light source. Flash, while it may alleviate the problem of color balance, often spoils the mood of a picture, and most color photographers prefer to try to balance the available light.

For a scene lit by a mixture of daylight and household bulbs, your film choice will depend partly on how the most important areas are lit. For example, if a window area is prominent, daylight film is preferable. But in most circumstances tungsten film is best because it is designed to provide good color with the longer exposures usually needed indoors.

Tungsten film is balanced for light with a color temperature of 3,200k – a tungsten photolamp, for example – and in studio conditions with all the lamps at this temperature, there is no need for filtering. Most household lighting, however, has a color temperature too low to give correct colors on tungsten film, as the chart at right shows. The result without filtration is a reddish cast, which becomes more pronounced as the color temperature lowers. A light-balancing filter cools down the colors and makes them appear more natural.

When lights of a different color temperature are mixed, filtering for one type creates a color cast in areas lit by another. You may be able to solve the problem by putting a sheet filter directly over one of the light sources, or you may have to compromise. One point to consider is whether a color cast really detracts from the image: to correct the color in a candlelit scene would require strong filters and thus a lengthy exposure; but you would probably prefer the warm glow of the unfiltered version.

Daylight-balanced film
Daylight film can be balanced for use in tungsten light with a blue No. 80A filter. However, it is preferable to load tungsten-balanced film.

The hues of artificial light
The chart at right shows a color temperature scale of various artificial light sources. The filters shown will restore the color balance when the light is too blue or too red to give correct color rendition on tungsten-balanced film.

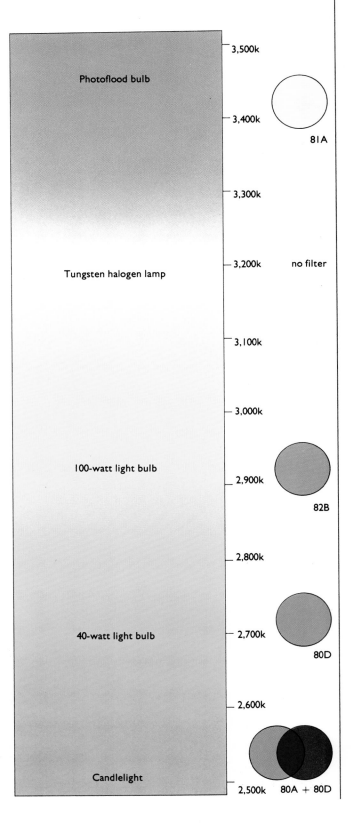

Photoflood bulb — 3,500k

— 3,400k

81A

— 3,300k

Tungsten halogen lamp — 3,200k — no filter

— 3,100k

— 3,000k

100-watt light bulb — 2,900k

82B

— 2,800k

— 2,700k

40-watt light bulb

80D

— 2,600k

Candlelight

2,500k — 80A + 80D

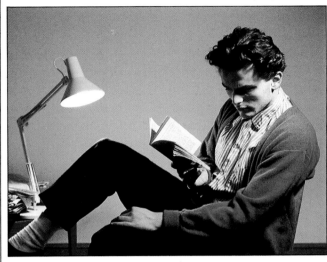

In domestic light
The photograph at left was taken in ordinary household lighting (a 100-watt tungsten bulb) on film balanced for tungsten light. A No. 82B filter cooled down the orange cast for the result below.

82B

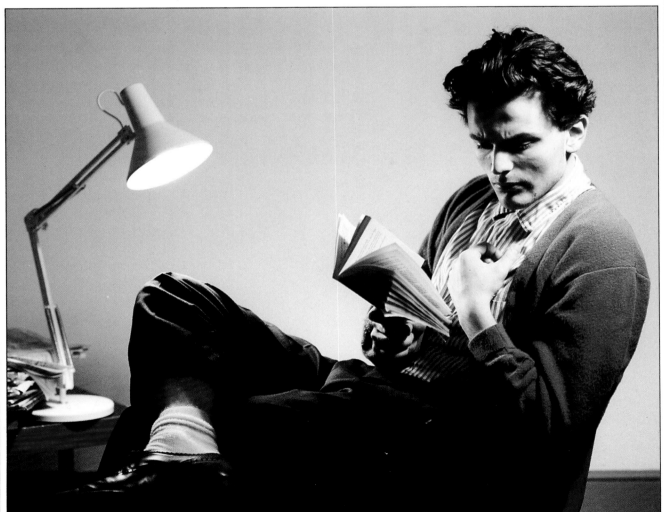

Metering color

It is usually not difficult to select the filtration that will adjust the color temperature of the light falling on a film. However, when light sources are mixed, as they are in the bank lobby shown below, you may find it harder to determine which filter to use.

If precision is important, you can either make test exposures and adjust filtration according to the color cast that appears on the processed film, or you can use a color temperature meter such as the one shown below. This device indicates the color temperature of the light source, either in kelvins or on a scale of units called mired values. The two scales of measurement run parallel in much the same way as do the calibrations in pounds and kilograms on a weight scale – except that kelvins and mireds run in opposite directions.

The technical definition of a mired is explained at far right. More important for photographers, however, are the practical advantages of the mired scale. Measured in mireds, filters have the same effect wherever they are used on the color temperature scale. For example, placing a No. 81EF filter over the camera lens always produces a mired shift of +52, whatever the light source. Compare this with the kelvin scale: the same No. 81EF filter produces a shift of 1,200k in sunlight but only 460k in tungsten light. In each example, the filter has precisely the same effect on film, but the mired system

Color temperature meters
A color temperature meter takes readings of red and blue light, and computes the color temperature by comparing the brightness of these two colors. The meter at right also measures green light. This expands the meter's capability to gauge nonincandescent light sources like fluorescent tubes, which may need green or magenta filtration to prevent a color cast.

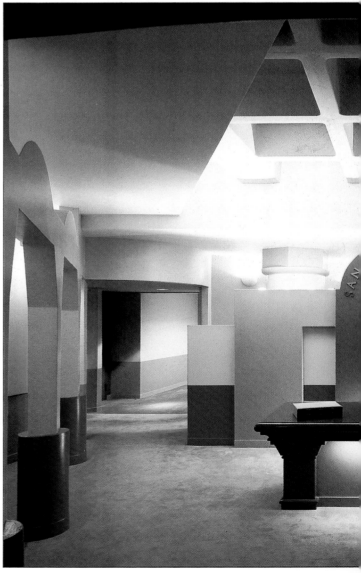

A bank interior (right) *was lit by four different-colored light sources, as diagrammed above. The photographer took color-temperature meter readings from the light sources and worked out the filtration for each area of illumination. Since this resulted in four different readings, he made four exposures on one frame. For each, he switched on just one of the light sources and used the corresponding filtration over the camera lens. The total exposure time was five minutes.*

offers photographers a much quicker, more convenient way of matching filter to light source.

In practice, a photographer simply uses a meter to read the color temperature of the light source, then subtracts this from the color temperature in mireds for which the film is balanced. The result is the mired value of the filter that must be used to obtain correct color. For example, if a meter indicates that a lighting scheme has a mired value of 302, and the daylight film in the camera is balanced for 182 mireds, you subtract 302 from 182 to get an adjustment of −120 mireds. Because shifts of less than 10 mireds are virtually undetectable, an 80B filter (−112 mireds) would provide sufficient correction.

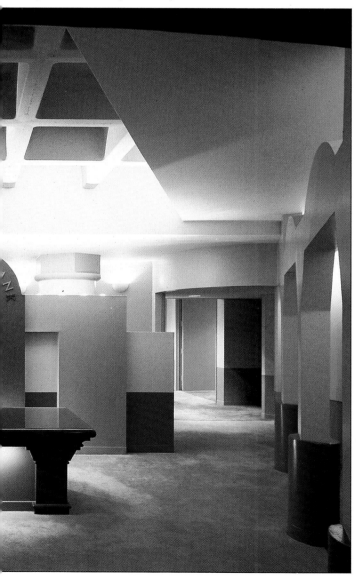

Kelvins	Light source	Mired value
16,000k	Brilliant blue sky, subject in shade	60
8,000k	Average summer shade	125
7,000k	Overcast sky	145
6,000k	Lightly overcast sky	170
5,500k	Summer sunlight/flash	180
4,500k	Early morning and late afternoon sunlight	225
3,500k	One hour after sunrise	285
3,400k	Photoflood bulb	295
3,200k	Tungsten-halogen lamp	315
2,900k	100-watt light bulb	345
2,700k	40-watt light bulb	370
2,000k	Sunset and sunrise/candlelight	500

Color temperature in mireds

To obtain a mired value, the color temperature in kelvins is divided into one million, so the two measurements run in opposite directions: a light source with a high kelvin value has a low mired value, as shown in the color temperature chart above.

Measured in mireds, the color shift produced by each filter in the Wratten series is constant, regardless of the color temperature of the light source. Thus, you can make up any mired shift (to within 10 mireds) using one or more of the filters, as shown in the chart below. Filters in the yellowish series increase the mired value; filters in the bluish series lower the mired value.

Mired shift value	Kodak Wratten filter number	Exposure increase required (in stops)
+9	81	$\frac{1}{3}$
+18	81A	$\frac{1}{3}$
+27	81B	$\frac{1}{3}$
+35	81C	$\frac{1}{3}$
+42	81D	$\frac{2}{3}$
+52	81EF	$\frac{2}{3}$
+81	85C	$\frac{1}{3}$
+112	85	$\frac{2}{3}$
+131	85B	$\frac{2}{3}$
−10	82	$\frac{1}{3}$
−21	82A	$\frac{1}{3}$
−32	82B	$\frac{2}{3}$
−45	82C	$\frac{2}{3}$
−55	80D	$\frac{1}{3}$
−65	82C + 82A	1
−81	80C	1
−89	82C + 82C	$1\frac{1}{3}$
−112	80B	$1\frac{2}{3}$
−131	80A	2

Fluorescent light

Most types of lamp use a heated filament to produce light and can be assigned a specific value on the color temperature scale. However, fluorescent and vapor lamps produce their illumination not from heat but from the glow of an ionized gas, and light from such sources does not fall exactly on the color temperature scale. As a result, the regular light-balancing filters – blue-colored 82 series and yellow-colored 81 series filters – do not provide complete compensation, and pictures taken by fluorescent light often have a pronounced color cast. Sometimes, this color cast does not matter, as in the example below, but when correct color is a priority, additional correction using red or magenta filters is essential.

The problem for the photographer lies in deciding just what filtration to use. A three-cell color temperature meter provides this information directly, but a simple alternative is to use one of the filtration tables supplied by film or lamp manufacturers. To make use of these, though, you must know which of the seven or eight types of fluorescent tubes is in use – and often the tubes are concealed by diffusing covers, or are positioned so high that the information printed on them is illegible. Ultimately, the only way to make sure that the color is correct is to make tests, as explained at right. However, remember that the filtration indicated by your trial film will be appropriate only for the location where you made the test: other fluorescent tubes, even in the same building, may be quite a different color.

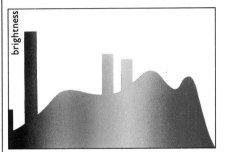

wavelength

Fluorescent light
Fluorescent light has a "discontinuous spectrum" – sharp peaks replace the smooth curve. Though we see the light as white, film reveals that some colors are totally missing. Full color correction is more difficult.

wavelength

Incandescent light
Incandescent light has a continuous spectrum – a mixture of light of all wavelengths. Our eyes interpret this mixture as white. On film, light-balancing filters can correct all but the strongest color imbalance.

Filtering and fluorescence
Only gelatin color compensating filters in an appropriate holder (1) will provide the optimum color balance with fluorescent light. But when color rendering is not absolutely critical, an FLD (fluorescent-to-daylight) filter (2) may suffice. When combining daylight and fluorescent light, cover the tubes with the appropriate acetate filter, sold in rolls by movie supply houses.

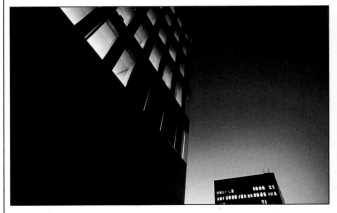

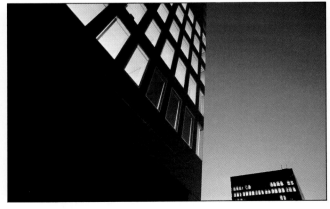

City windows at night are tinted green by interior fluorescent lights (right). But colored lights at night are often appealing in photographs: corrective filtration (left) makes the buildings appear much less colorful.

50M+10C

30M

40M

50M

A corrective filtration test for fluorescent tubes
For his test, the photographer of these pictures on daylight film used magenta filters with values of 30, 40 and 50. A 50 M produced the best result (at right, bottom) but the picture was too yellow. Adding a 10 cyan filter yielded near-perfect color in the final image above.

Color in low light

In most normal conditions, exposing color film in accordance with a meter reading produces a picture with accurate colors and tones. But in dim light you may have to adjust exposure and add filtration to prevent your photographs from looking dark and poor in color.

This is because, when exposures are a second or longer, the intensity of light is too weak for the film to respond as it usually does. Normally we expect film to react uniformly, so that halving the shutter speed and simultaneously opening the aperture one stop would have no effect on the overall exposure.

In dim light, this rule – called the reciprocity law – breaks down: the speed of the film effectively drops and the color balance may shift. The result is known as reciprocity failure.

To compensate for film's loss of sensitivity in low light, you should give extra exposure and fit color compensating filters over the lens, as explained below at left. Exactly how much compensation you need varies from film to film, as shown in the chart opposite. Exposure compensation may be necessary whenever the meter needle passes the one-second mark. Furthermore, you should make the correction by

Compensating for low light

f/2 ⅛ second

f/22 16 seconds

f/11 16 seconds

f/11 16 seconds + CC10B

With the camera loaded with Kodachrome 25 film and set at 1/8 at f/2, this dimly lit still-life was correctly exposed but depth of field was inadequate (top left). Closing the aperture by seven stops to f/22, and extending the exposure by a corresponding amount – to 16 seconds – kept the whole scene in focus, but reciprocity failure caused underexposure and a slight yellow color cast (top right). Opening the aperture by the two stops recommended for Kodachrome 25 film, as shown in the chart opposite, corrected exposure (above left), but filtration of CC10 blue was also necessary for accurate color rendition (above right).

opening up the aperture, not by prolonging exposure. If your lens is already set to its maximum aperture, as it may be in dim light, consider using faster film or pushing the film at the development stage.

Color compensation is not usually as important as exposure compensation, and with color negative film you can make some adjustments at the printing stage. In a night scene, such as that of the river and bridge below, nobody expects to see precisely natural color, so you can effectively ignore the color shift caused by reciprocity failure: indeed, a color shift will often give an image greater impact.

FILM	Exposure adjustment (in stops) and filtration		
	1 second	10 seconds	100 seconds
Ektrachrome 64	+½	—	—
200	+½	—	—
400	+½	+1½ CC10C	+2½ CC10C
Kodachrome 25	+½	+2 CC10B	+3 CC20B
64	+1 CC10R	—	—
Ektachrome 160 (tungsten)	+½ CC10R	+1 CC15R	—
Kodacolor VR 100 & 200	+1 CC10R	+2 CC10R+10Y	—
VR 400	+½	+1	+2
VR 1000	+1 CC10G	+2 CC20G	+3CC30G+10B

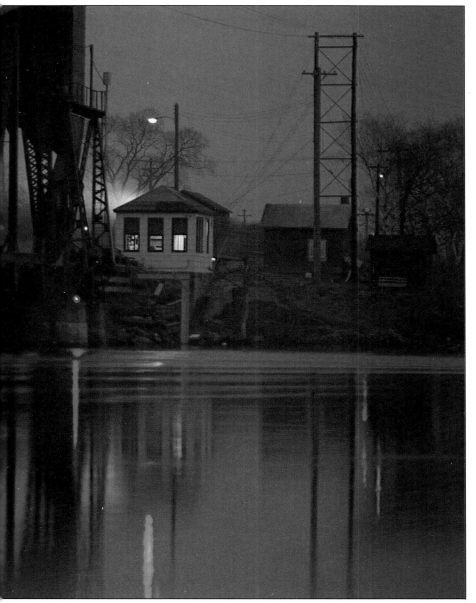

Exposure and filtration
The chart above shows how much you should open your camera's aperture when exposure time exceeds a half-second. If filtration is needed, this is also shown, in Kodak Wratten color compensating filter values. The dashes indicate when such long exposures are not recommended with a particular type of film. If exact compensation is impossible because you have no reciprocity information for the film you are using, try adding a ½-stop for a one-second exposure, 1½ stops for 10 seconds, or 2½ stops for 100 seconds, without filtration.

A river crossing was so dimly lit that the photographer had to prolong the exposure for many seconds. Following a meter reading in such circumstances could have been disastrous, leading to considerable underexposure. By adding an extra two stops exposure, the photographer avoided this, but he chose not to correct the expected blue color cast – which ultimately added to the moody atmosphere of the twilight scene.

Precision exposure

For optimum results color slide film must be correctly exposed, and in sunny weather the margin for exposure error may be as little as half a stop over or under the correct setting. With average subjects, such precise exposure control is well within the capabilities of a camera's built-in meter, but subjects that are predominantly dark- or light-toned can easily mislead a built-in meter that measures reflected light.

In such difficult situations, a more reliable method of setting exposure is to measure the incident light – the light falling on the subject rather than the light reflected from it. Incident light metering is simple with a handheld meter, as the diagram below at left shows. All handheld meters are specially equipped to handle this function.

If you do not have a handheld meter, or perhaps if you are traveling light, an alternative way to establish the precise exposure is to use your camera's meter in combination with a specially printed Kodak gray card. By holding this in front of your subject and measuring the light reflected from the gray surface, you eliminate any influence that subject tones might have on the meter reading. Alternatively,

Diffusing dome

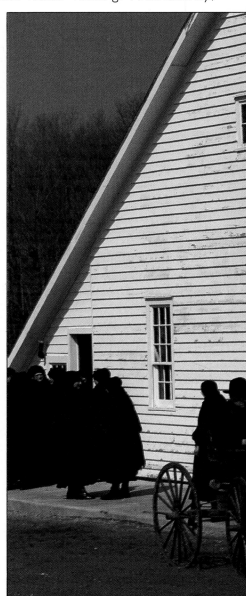

Alternative
cover for reflected
light readings

Handheld exposure meters
Almost all handheld meters can measure both the light reflected from a subject and the incident light.
To make incident light readings, the photographer fits a translucent dome over the light-sensitive cell. In the picture at left, the dome is shown attached to the meter; shown above is the window that replaces the diffusing dome when the meter is used for regular reflected light readings.

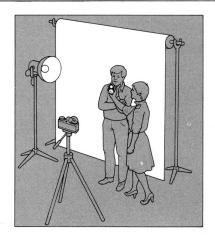

Metering incident light
When using a light meter to measure incident light, hold the meter close to the subject and point the diffusing dome back at the camera, not at the light source.

Using a gray card
Hold the card in front of the subject, with the gray side facing the camera. Move forward until the card fills the frame, take a reading, then move back to recompose the image.

take a reading from the palm of your hand or from non-shiny brown wrapping paper – both have approximately the same reflectance – and give one stop more exposure.

Using a gray card or an incident light meter usually means moving close to the subject to take a reading. When this is impossible, hold the meter or gray card in lighting similar to that illuminating the subject. If you are careful about the direction of the light in relation to the camera position, this substitute reading technique can be almost as accurate as a meter reading taken at the subject position.

A sunlit meeting house contrasts brilliantly with the clothes of the faithful gathered outside, creating a pattern of black and white that is bound to mislead any reflected light meter. By using an incident light meter instead, the photographer measured the intensity of the sunshine falling on the scene and thus recorded all parts of the subject in the correct tonal relationships.

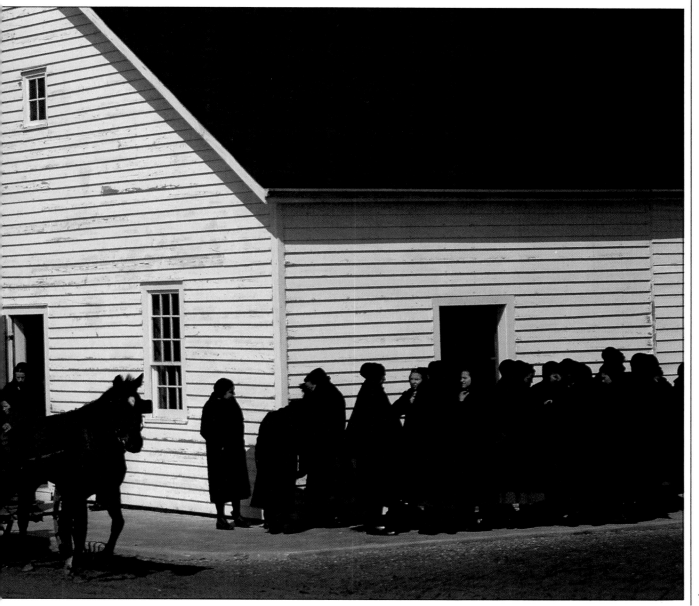

Exposure control

Although you should get into the habit of accurate metering with color slide film, sometimes a setting slightly below the meter reading will give a better result. Excessive underexposure produces images with inky black shadows and muddy colors, but underexposing by just one-third or one-half stop can give richer, denser colors and a more differentiated range of highlight tones. Indeed, many photographers prefer to underexpose slide film all the time, keeping their cameras on the automatic mode with the ISO dial set to double the film speed. Although this causes some loss of shadow detail, it also provides maximum color saturation.

Underexposure can be especially effective with brightly colored abstract pictures, or when you want to create a brooding, moody effect, as in the pictures at bottom and opposite. A degree of underexposure is also useful if you plan to submit your pictures for publication: printers generally prefer working from a rich, dense transparency.

Overexposure with slides is generally less fruitful than underexposure because it gives pale, washed-out colors and poor highlight detail. However, occasionally it can produce an attractive pastel effect or convey an impression of blistering heat, as in the view immediately below.

Two figures on a beach soak up the sun (left). Using Kodachrome 64 film, the photographer exposed at 1/500, f/5.6 – one stop more than a meter reading for the sand showed. The burned-out sea and sky reinforce the impression of heat.

Yellow umbrellas (right) form a rainproof roof above a party of schoolgirls visiting a temple in Japan. Underexposure by a full stop sacrificed shadow detail and muddied the yellow hues but added to an atmosphere of dampness and gloom.

Dark gray clouds (below) scud over a cornfield. The photographer underexposed by a half-stop to create a mood of stormy menace.

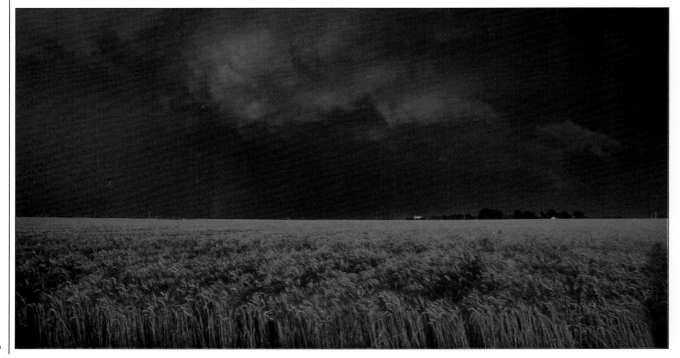

Control through development

Just as you can subtly affect color on slide film at the picture-taking stage by under- or overexposing, you can make useful *corrective* adjustments during processing. Extending or reducing the development time ("pushing" or "pulling back" the film) can dramatically affect the film's performance.

Normally, the aim of pushing slide film is to increase the effective film speed: by increasing development time you can compensate for underexposure. This facility is especially useful when the light is too dim to allow a shutter speed fast enough

to freeze movement or an aperture small enough to provide sufficient depth of field. If you do your own processing, follow the development times specified below. Alternatively, ask a laboratory to make the necessary adjustments.

Pushing slide film increases contrast, as shown below. This can be useful if you are taking pictures on a dull day, when contrast is usually poor. However, be careful not to overdo the technique; pushing by more than two stops tends to soften colors unacceptably. Pulling back slide film, conversely,

Adjusting development: Process E6

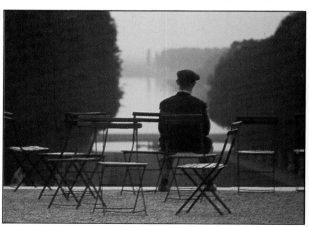

Overexposure, underdevelopment
The photographer of the lakeside view at top followed an incident light meter reading and gave the standard first development time of seven minutes. For comparison, he took the image immediately above on a second roll of film just a few minutes later. Overexposing by one stop and reducing the first development time to five minutes has reduced the contrast, creating a softer, more pastel effect appropriate to the subject.

Underexposure, overdevelopment
The view of a farm building at top was normally exposed following a meter reading, and given the standard first development time of seven minutes. This produced a rather flat-looking picture, despite the inherently high contrast of the subject. For the second image (immediately above) the photographer underexposed by one stop and extended the first development time to nine minutes. This increased the contrast, and added impact to the picture.

reduces contrast; by this means you can improve an excessively contrasty subject to create a soft-looking image such as the one at top right on the opposite page. Again, a gentle touch is needed or the colors will look muddy.

The picture below shows how you can make creative use of the increased graininess that results from pushing slide film. Taking this technique to its limits with fast film, you can produce soft, shimmering pictures that are reminiscent of the Autochrome color plates of the early 20th Century.

A rowboat on a sandy beach dominates two graphic wide-angle views. The picture at the top of this page, taken on ISO 200 slide film, which was exposed and developed normally, shows the scene in a lifelike way. But for the picture above, the photographer pushed the film by four stops for a more subjective interpretation – a grainy, high-contrast image with muted colors. The increased grain shows the midtone area where the boat's shadow falls as a mass of tiny colored dots and adds to the texture of the sand.

Using instant color film

Instant color materials have an obvious appeal for anyone interested in rapid results. Yet they also have significant uses in professional photography. Many photographers take instant pictures to make visual notes of locations, to give to models or other helpful subjects, or to test composition. Some large-format cameras can be fitted with interchangeable Polaroid backs, allowing you to choose from the camera's whole range of exposure settings; this means that a studio photographer can use instant film to test lighting and exposure before taking the final picture. Moreover, with an imaginative approach, even the apparent limitations of instant film can be used creatively as in the large composite picture below which unites a series of individual moments into a complex image that conveys the experience of time.

Today's instant color films have an excellent color response. Although greens tend to look duller than they are in reality, skin tones usually record well – sometimes better than with conventional color print film. To control exposure, you can use the lighten/darken dial found on most instant cameras as shown below at left. This dial also helps provide a measure of control over color in extremely warm or cold conditions.

Adjusting exposure

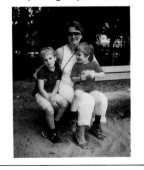

Normal range of tones
In a scene where all the highlights and shadows are well balanced, set the camera's lighten/darken dial to its midpoint. This will give optimum color rendition and produce maximum detail in both the highlight and shadow areas.

Dark subject, light overall
With a dark subject in a scene that is predominantly light, overexpose for best results. Simply turn the dial, which is marked in half-stop stages, to reduce the black area visible. You should also "lighten" at temperatures above 85°F (30°C).

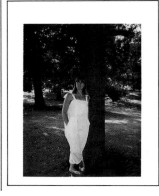

Light subject, dark overall
When the main subject is light but the surroundings predominantly dark, you must underexpose by turning the lighten/darken dial to reduce the visible white area. You should also "darken" at temperatures below 60°F (16°C).

The quality of instant color
If you compare an instant color print with the original scene, as at right, you may be unhappy with the color rendition. However, this is only because you have the opportunity to make a direct comparison: most conventional color print films would show similar inaccuracies if they were submitted to such a rigorous test of color fidelity.

A composite view of a Los Angeles swimming pool (below), made up from 120 instant color prints taken on successive frames, stretches the creative potential of the medium to an unprecedented degree. In this complex image English artist David Hockney has dynamically conveyed the experience of watching a swimmer cover several lengths of a pool.

Fine-tuning film

Although color slide films are designed to produce consistent results, different batches of the same film can sometimes show small variations in film speed and color response. If you want precise color rendition and an exactly repeatable result, you should reduce these variations to a minimum.

All color films age in storage, but they age more quickly if they are subjected to heat; moreover, the emulsion layers may age at different rates, thus affecting color balance. Films for general use are often stored for long periods in uncontrolled conditions, both in the store and after purchase. Manufacturers take such a time lag into account and design their amateur films to "ripen" slowly and reach optimum performance after leaving the factory. However, for critical use with color slide film you can use "professional" films, such as Ektachrome 200 Professional film. These films are designed to be stored in a refrigerator and then exposed and devel-

oped immediately for best results. If you follow the requirements of storage and usage described in the box below, you can be confident with professional film that your slides will be fine-tuned to the optimum color balance. Color negative films are not usually available in professional versions because final control of color can be made during printing.

To be even more sure of consistent color quality, buy professional film in batches and use the first roll of each batch to make a color test. You can use this test to determine what filtration, if any, will be necessary when you expose the rest of the batch.

First, using flash, photograph the color chart on the opposite page, as described in the accompanying caption. After processing, compare the slide very carefully with the chart. If there is a slight color cast, you can correct this in advance on subsequent film from the same batch by using the appropriate color compensating filter.

avoid moisture condensation on the film, allow it to warm up to room temperature before opening the package. Store *exposed* film in a cool dry place and process as soon as possible after exposure. Protect *processed* film from strong light and store it in a cool, dry place.
Like other dyes, the dyes used in 'Kodak' colour materials may change in time.
Kodak, Ektachrome and Wratten are trade marks

EFFECTIVE SPEED ASA 64/19 DIN

Para dispositivas en color	Para Proceso E-6	Español

El precio de la película no incluye el procesado. *Cargue y descargue la cámara en luz tenue.*
35mm: Si la película tiene una lengüeta corta, la longitud total de la película permanece inalterable. Para cámaras que requieren lengüetas largas utilice guía empalmable.
Equilibrada para: Luz día, flash electrónico o bombillas de flash azul. Fuente de luz normal para visión = 5000°K.
Ajustes de Fotómetro: basada en emulsiones promedio utilizadas bajo diversas fuentes de luz. En la hoja de instrucciones que aparece dentro de este paquete, la información sobre el número específico de la emulsión de la película se encuentra en el apartado "EFFECTIVE SPEED".

FUENTE DE LUZ	AJUSTES DE FOTOMETRO	FILTRO KODAK 'WRATTEN'
Luz día	ASA 64/19 DIN	Ninguno
Fotolámpara (3400°K)	ASA 20/14 DIN	

Using professional films

Professional film is available in 35mm daylight versions in a variety of film speeds. With Kodak Ektachrome and Kodachrome Professional films, the exact speed, which may differ marginally from the nominal speed, is tested for each batch and printed in red on the instruction leaflet as shown at left. This facilitates precision exposure.

You should store professional films in a refrigerator until you need them. If you intend to store film for more than two months, use the freezer, as shown above. When you remove a film, let it warm up for at least 1½ hours before taking it out of its film can; if it has been in a freezer, allow at least 2 hours.

Color-testing film

You can use the chart at left to color-test any slide film. Because daylight may not be exactly repeatable, it is preferable to photograph the chart by flash. The easiest way to compare the resulting slide with the original colors is to view the slide on a light box, as shown above at left. Ideally, an exposure reading from the light box should show 1/60 at f/5.6 when the ISO dial is set to 100; this corresponds to the color and intensity of the light source used by printers when they are viewing slides for reproduction. If you are dissatisfied with the slide's color rendition, use color compensating filters to determine the filtration that will produce an acceptable result. Simply look at the test slide through different CC filters until you find one that eliminates the color cast. Use this filter for all exposures made on the same film batch.

Rescuing a slide

Despite every attention to exposure and processing, many slides still come out too dark or light, or with an unwanted color cast. Some are worth rescuing, and you may be able to do this by judicious copying as described below.

Before trying to use the copying process to correct faults, you must standardize your copying equipment and procedure so that you can make a good copy from a correctly exposed slide. The sequence below shows a straightforward routine for doing this with an inexpensive copying tube.

Once you have taken a test roll to establish the correct exposure and filtration for a good slide, you can turn your attention to your less satisfactory images. Dark and light images are easiest to remedy; simply cut or boost the copying exposure in proportion to the density of the original transparency. Dark images produce the best results when copied:

slides that are too light do not show such a marked improvement.

To remove a color cast, place a filter between the light source and the slide. You can use inexpensive acetate color printing filters for this purpose. Choose a filter that has a color complementary to the cast on the original slide and experiment with several densities, because it is often hard to guess the precise correction required just by examining the original image.

Unless you take special precautions, contrast will increase when you copy a slide. You can harness this effect to brighten colors and add sparkle to pictures taken on a dull day, as shown at right. If you wish to avoid an increase in contrast, load a film that is specially designed for copying, such as Kodak Ektachrome slide duplicating film SO-366, or use equipment that has a contrast-reduction component.

Making an exposure test

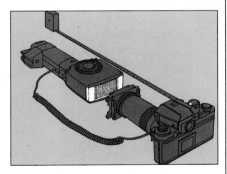

1 – Start by attaching the copier to your camera, just as you would a lens. Most simple copiers are fixed-focus; but if yours is not, you should adjust the magnification and focus according to the instructions supplied with the unit.

2 – Choose a test slide that is correctly exposed and completely free of color casts. Place the slide in the copier so that the image appears the right way around in the viewfinder, and load the camera with a roll of film.

3 – Place the assembled copier on a sheet of black paper or cardboard on a table. Stretch a tapemeasure across the table and link a small manual flash unit to the camera using an extension cable. This should be about a yard (1m) long.

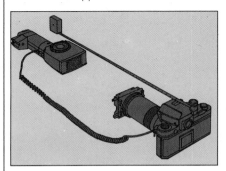

4 – Directing the flash at the copier, make a series of exposures. Move the flash progressively farther away, and position it at distances equal to the numbers on an aperture ring – 2 inches, 2.8, 4, 5.6, 8 and so on.

5 – Take notes of everything you do. Once the dupes have been processed, compare them with the original and pick the best copy. From your notes find out how far apart the flash and copier were when you made that exposure.

6 – When copying unsatisfactory slides use this distance as a starting point. Move the flash closer to the copier with underexposed slides, farther away with overexposed slides. Place filters over the flash (as shown above) or behind the slide.

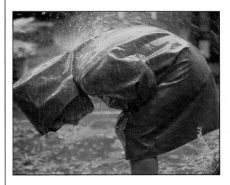

Altering exposure

This is the simplest way of copying corrections. The slide above was much too dark, with muddy hues, but an extra stop of exposure in copying restored much of the lost color (right).

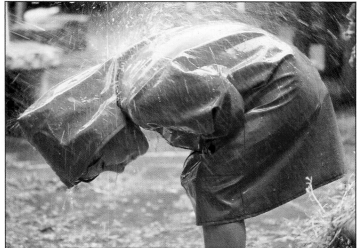

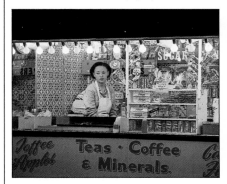

Altering color

This may require more trial and error but is equally successful. The orange cast created by tungsten light (above) was corrected here with the use of blue filtration (right).

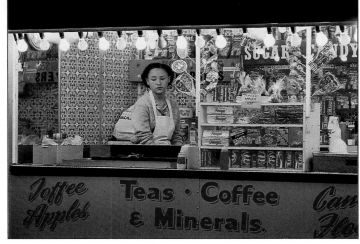

Altering contrast

This is a useful way to brighten colors. The photographer copied the slide above onto regular film to take advantage of the increase in contrast that he knew would occur (right).

HOW COLORS BEHAVE

Color film is a modern miracle. It is capable of producing remarkably subtle and lifelike images, like the one at left, in an instant. But no matter how good they look, the colors in a photograph can at best be only a close approximation of reality: they can never duplicate all the colors of a scene with exact fidelity.

Films record some hues more faithfully than others. Skin tones and pale tints usually appear correct, but some primary colors can seem washed out, and others look more saturated on film than they do to the eye. To explain which colors work best in photographs, the following section looks individually at the most common colors of the natural and manmade world, and shows how you can optimize the ability of film to record each one.

However, using color effectively is not just a matter of being able to predict when color film will give the best results. Human considerations also have some bearing on how color appears to the eye. So the section begins overleaf with an outline of the more obvious vagaries of human vision and shows how psychology and symbolism can affect the way in which people respond to color pictures.

A patchwork of color springs from a wall of prisms that surrounds the lamp of a lighthouse. The vivid spectrum that appears in the photograph testifies to the abilities of today's color film. To provide maximum color saturation, the photographer chose slow color slide film – Kodachrome 25.

Color moods and meanings

Colors have long been known to arouse moods and even emotions in the beholder. Many people find it difficult to live or work in a room decorated in a hue that they regard as unpleasant or inappropriate. Surveys have shown that people generally prefer light colors to dark ones, and that they like colors in the blue range best and greenish yellows least. When two colors are displayed side by side, combinations that are dissimilar in brightness and hue, such as those in the picture below at right, are usually received more favorably. Some colors are perceived as relaxing or arousing. Almost every theater used to have its Green Room to help artists relax before or after a performance. Red, on the other hand, is seen as active, even aggressive.

The reasons behind such reactions may be partly physiological. The focal point of red-light wavelengths lies behind the retina of the eye, so that red literally advances, making red objects seem closer than they are. As explained in the box below, red is experienced as the "heaviest" of colors.

Many experts also make connections between our responses to colors and their associations with the natural world. Russet tones suggest the ripeness of autumn, earth colors conjure up reassuring solidity, while green suggests new growth, as in the photograph opposite, below. Some reactions, too, may be based on traditional color symbolism, although the significance of colors may vary according to region or context; for example, in the West white is linked to purity, but in China it is the color of mourning.

Color psychology is not yet an exact science. However, photographers who use the tentative findings of color scientists to supplement or confirm their own intuition will often be able to obtain more controlled responses to their pictures.

An outdoor still-life (above), with squashes and cabbages placed against a blue wall partly in shadow, presents a pleasing arrangement of colors and shapes. The contrasts of hues, and of dark and light tones within each hue, contribute greatly to the satisfying effect of the image.

The relative weight of colors
Colors appear to have different visual "weights." Red is generally perceived as the heaviest, followed by orange, blue and green (which are roughly equal), then yellow, then white. Thus, the diagrams at right, based on the results of experiments with volunteers, show how varying amounts of white are needed to balance equal amounts of red, blue and yellow. The relative weights of colors can play a role in composition. For example, the image of neon lights above appears visually stable, but if the red and green were reversed, there would be an unsettling imbalance. Color weight also modifies the perception of size; "heavier" colors make objects appear smaller.

A sports car straddling the center of the road speeds toward the camera (left). Because red is a commanding, aggressive color, it is commonly used for fast cars. Yellow, however, is more eye-catching when placed against a neutral background, which explains why it is often favored for road markings.

Green cones rise against a painted sky in a mural on the office building of a paper corporation. Although the cones' shapes are far from natural, their color symbolism suggests springtime growth – the renewal of the forests after trees are felled for paper.

Red

Red is a vibrant color, and just a small patch of it is enough to bring a spark of life to a picture, as the image below illustrates. Photographs dominated by brilliant red can be arresting or exciting, but are rarely peaceful or soothing. For example, the picture of the door, opposite, might be appropriately dynamic on the wall of an advertising agency, but would be unlikely to calm the nerves of patients in a dentist's waiting room.

Film records pure primary red hues relatively faithfully, but if a subject is brightly and evenly lit, its tones in the picture may sometimes seem to blend together. For example, if the subject is a red flower, the shape of the petals may be difficult to distinguish. To get around this problem, try using directional lighting, as on the opposite page at far right, so that shadows and highlights break up the uniform tones of red; alternatively, you can try underexposing the film by about a half stop.

Often, red can function well to provide a color accent, as in the picture at right, above. In this case, the priority is not maximum detail, but optimum color saturation. This is best achieved by taking pictures using a hard light source like direct sunlight and by using a polarizing filter.

A whitewashed gable with red trim (above) makes a bold chevron against the sky. A polarizing filter darkened the sky and the woodwork. The extreme contrast in the scene would have misled the camera's TTL meter, so exposure was judged instead by an incident light reading.

A mailbox in rural England (below) catches the eye with its angular shape and brash color. The muted hues of the wall and the snow-clad landscape behind it make the splash of red even more emphatic, so that it seems almost to float above the surface of the picture.

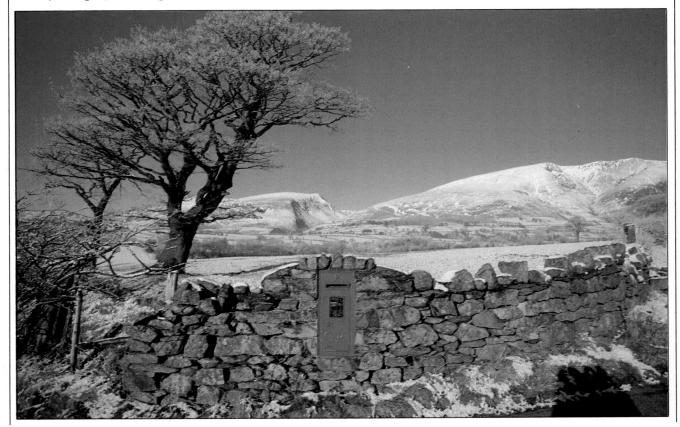

A rose (above) makes concentric rings when photographed through a macro lens and extension tube. To enhance detail in the brightly lit petals and to emphasize their gentle curves, the photographer sprayed the bloom with water from an atomizer.

A sunlit door (left), painted brilliant scarlet, fills the frame with its warmth and color. By moving in close to the door, the photographer excluded other hues that would only have detracted from the image's monochromatic power; however, he retained the magazine as a focus of compositional interest.

91

Blue

Deep blue is the color of the sky in fine weather, a cool hue that sets us at ease. For the photographer, though, blue has other values. Blues seem to recede, suggesting distance, and for this reason they make good background colors – particularly if there is a brilliant warm hue in the foreground.

Color film does not always record blue hues exactly as the eye sees them, particularly if they are richly saturated. However, the color "errors" that film makes do not always matter. Indeed, they may actually work to the photographer's advantage. For example, light from the sky is very rich in ultraviolet (UV) radiation, which affects only the blue-sensitive layer of color film and thus adds to the exposure made by blue light from the sky, making the sky seem extra blue in the final picture. Such deep blue skies generally improve the appearance of a photograph, as the main picture below shows; but for a

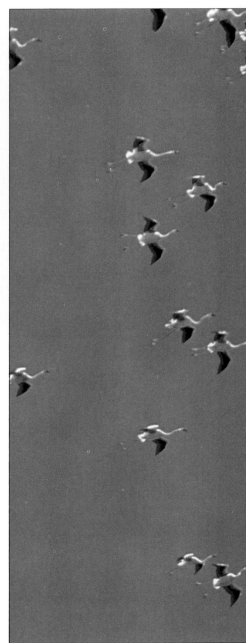

Blue rope, lying tangled on a pier, contrasts with the pink-red hues of a float. Choosing this blue, apparently receding, background gave the picture a strikingly three-dimensional feeling.

Massed bluebells (left) carpet a woodland glade. In this photograph the flowers appear more purple than they would in nature. Filtration would have corrected the color of the flowers, but it also would have made the other hues look completely unnatural.

An azure sky (right) forms a vivid backdrop for a flock of flamingos. To increase the blue color's intensity, the photographer exposed at one stop less than his camera's meter indicated.

more literal rendering, use a UV filter.

Blue flowers occasionally present problems, too. Many of them strongly reflect very deep red light. Though our eyes are almost blind to such deep red hues, film is not, and the flowers sometimes appear a different shade of blue, as in the picture at bottom left. However, the color shift is usually slight and will pass unnoticed unless the flowers and the photograph are viewed side by side.

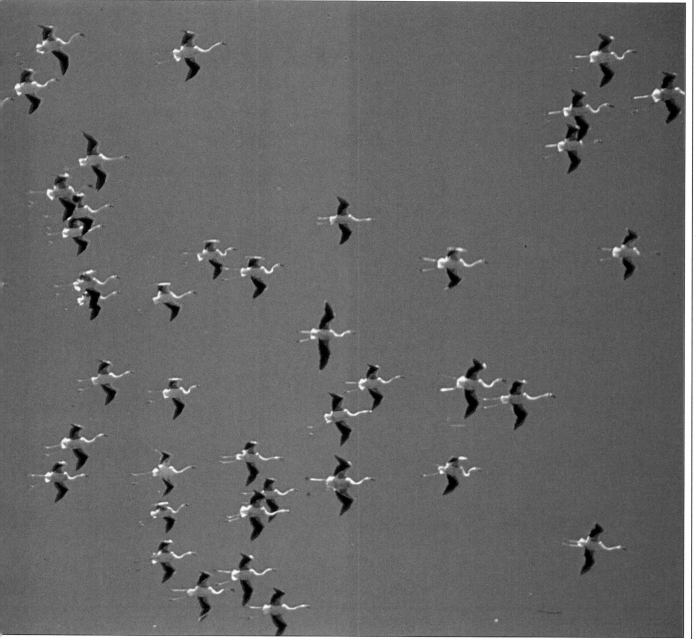

Yellow

Yellow has the highest reflectivity of all colors, and is always prominent in a picture. It is the only hue that is brightest when fully saturated; all other colors darken. Pictures dominated by yellow, such as the large image on the opposite page, tend to be optimistic in mood.

Yellow is the most difficult color to reproduce in photographs, for two reasons. Sensitivity to yellow light is shared by the two lower layers of the emulsion, but they are most sensitive to red and green. This means that yellow has less effect on film than on the eye. Second, yellow is the purest of the three dyes in color film; the other two dyes, cyan and magenta, themselves contain some yellow. So to prevent neutral grays and skin tones from looking too yellow in a photograph, manufacturers limit the amount of yellow dye in film, with the result that the yellow areas of a subject often look pale and desaturated.

Unlike other hues, yellow does not benefit from underexposure, which simply makes the color look muddy. Instead, you can increase color saturation by using a polarizing filter if the subject is shiny, as on the opposite page at far right. Or, if yellow is the only strong color, as it is in the picture below, you can use a yellow filter.

Mustard flowers (above) cut slashes of acid yellow across a verdant landscape. A 200mm lens compressed the receding planes of the image, so that the fields appear as flat areas of color. This was the brightest of three bracketed exposures.

Silhouettes (below) break up a broad expanse of yellow, which was rendered more brilliant by the use of a yellow-colored No. 81C filter. Placing the figures high in the frame, the photographer also emphasized the wall's reflection in the shiny floor.

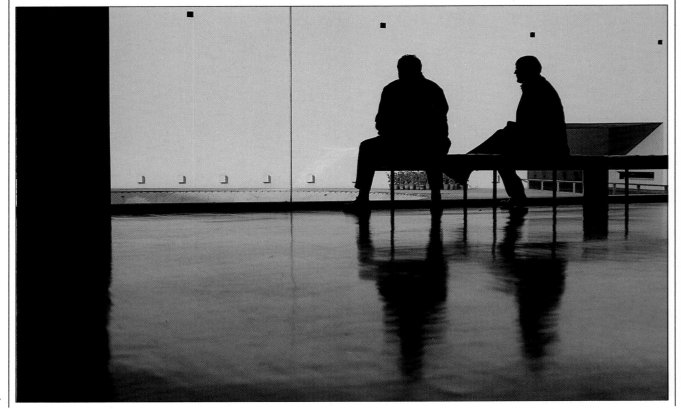

A yellow balloon (above)
*drifts serenely overhead in
a clear blue summer sky. By
using a polarizing filter, the
photographer both darkened
the sky and eliminated glare
from the balloon's fabric,
thus enhancing the contrast
between the colors and
creating a vibrant effect.*

A stationary truck (left)
*risks a ticket, but neatly
matches the curb markings
that prohibit parking. Bright
sunlight enhanced the
dominant yellow hues,
which gave the image a
cheerful, exuberant feel.*

Green

A palm leaf (below) spreads
out like a fan. To emphasize its
ribbed structure, the photographer
stood in the shade of the tree, so that
sunlight shone directly through the
translucent fronds.

Of all nature's hues, green is the most varied. Some trees are so dark a green that they may appear almost inky from a distance, while the newly opened leaves of many plants are the very palest of greens. Part of the pleasure of looking at many landscape photographs comes from the restful harmony of dozens of different shades of green, as in the picture opposite. Weather varies noticeably the color of green, and so does time of day, as shown by the differences among the pictures of a field below.

A fortunate consequence of this diversity of greens is that people are prepared to accept a large variation in the appearance of foliage in photographs. Unless the picture is held up in front of the scene it represents, there is no easy way to tell whether or not the film has truthfully recorded the colors of grass or leaves. Despite this wide tolerance of variations in the reproduction of green hues, it is always worth aiming for the best possible color rendering. In sunlight, you can improve the appearance of foliage by using a polarizing filter, which removes glare from the leaves, making them look richer and deeper in color. Ultraviolet radiation from a blue sky can make vegetation too blue on film, but a skylight filter will remove the UV element and thus restore a more natural color balance.

When sun shines directly through leaves, as at right, greens can look particularly fresh and clear. Take special care with exposure, though, or the shafts of sunlight may mislead your meter into underexposing; bracket to ensure a good result.

Dawn

Early morning

Noon

Late afternoon

Dusk

Green hues and daylight

As the sun and clouds move across the sky, daylight changes in color and direction – and this in turn affects the colors of foliage. These pictures were taken without any filtration, yet the same green field of corn varies from ocher to olive. Compared with such natural alterations in color, any shifts caused by film are insignificant.

***Lengthening shadows** delineate every furrow in a rich agricultural landscape. To cut down reflected light that would have masked the lush greenness of the scene, the photographer used a polarizing filter.*

Gray and black

Gray and black, because they are associated with neutral hues or with the absence of colors, are often neglected by color photographers. Yet a really rich black can bring a color picture to life. And blacks and grays can make attractive compositions even when little or no other color is included, as in the two photographs on these pages.

Surprisingly, gray is a hue that film manufacturers take particular trouble to render accurately. This is because the eye is especially intolerant of color casts in gray areas. Light that is too yellow or too blue has a marked effect on gray, giving it warm or cool color tinges that may look unacceptable on film. Different colored surroundings also affect how the hue appears, as the illustrations opposite demonstrate. If you wish to record accurate or near-accurate grays on slide film, it may be worth taking a test picture, having it processed and then returning to the subject to take a second picture with the appropriate filter over the lens.

One of the main advantages of including black in a color photograph is that, by contrast, other colors look brighter and more saturated. Conversely, including an area of white or a light color in a photograph will make a dense black stronger and richer by contrast. However, to bring out detail in a black subject, high contrast is not desirable. Instead, choose dark surroundings: with the whole scene brightly lit, you can then use extra exposure to reveal subtle details and tonal differences.

A catch of fish (above) provides a harmony of subtle tonal variations. The photographer realized that the overcast sky would give the grays a blue cast, but guessed that this would not spoil the impact of the image.

The effect of colors on gray
Our judgment of colors is influenced by surrounding colors. This is especially evident with gray, as shown here. Against black, gray appears at its most neutral. But against a color, gray is tinged with that color's complementary. Thus, red gives gray a cool, bluish cast; while cyan produces a warm, brownish hue.

A portrait of a man astride his motorcycle gains in impact from a deliberately restricted range of hues. Under overcast lighting, it would have been difficult to retain detail in both the black leather jacket and the flesh tones. However, strong sunlight created reflected highlights on the leather, so the photographer was able to choose an exposure that suited the man's face as well as brought out the texture and rich black of his apparel.

White

The cool freshness of white can look as attractive in a photograph as any of the primary colors. But to reproduce accurately a white subject such as the steps opposite, you must ensure that traces of other colors do not tarnish its purity.

Sometimes this is tricky, because white reflects the colors of its surroundings and of the light source so clearly. When color temperature is particularly high or low, white areas pick up color casts that may not be noticeable in more colorful parts of the subject. For example, in the picture below at right, the sunlit white wall shows up the yellow hues of sunset, but the red door looks perfectly natural. However, such color temperature differences are simple to rectify using color correction filters, as described on page 64.

Color casts may be particularly evident in shadowed areas of a white subject. Here, prevention is better than cure, and for this reason it is a good idea to avoid wearing brightly colored clothing in the studio when photographing a white still-life subject. However, sometimes it is impossible to control the colors of the surroundings – particularly outdoors. For example, in the picture at right, the blue sky has colored the shadows of the snow. The best way to deal with this problem is to keep shadowed areas to a minimum, or else let them dominate the picture completely, and then base filtration chiefly on the shadows to correct the resulting color cast.

Exposure for white subjects is more difficult than for less reflective subjects, because reflected light meters are easily deceived both by large areas of white and by white subjects on dark backgrounds. For best results, use an incident light meter, or take a reading from an 18 percent gray card.

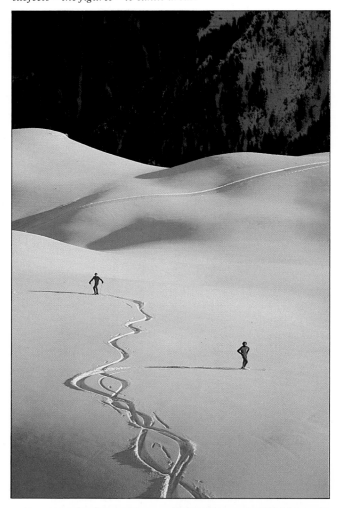

An ornamental urn (above) appears unnaturally white against its background of yew hedges, because the dark foliage misled the camera's meter, causing overexposure. Shadows on the urn pick up the green of the vegetation.

A whitewashed store (left) turns a creamy yellow as dusk approaches. To correct the color cast, the photographer made a second exposure with a No. 82C filter over the lens – but preferred the warm hues of this first, unfiltered picture.

Tiled steps (above) zigzag across a wall, breaking up the expanse of white into areas of light, shade and line. Deep blue sky behind the wall and dark vines in front of it seem to make the white glow brilliantly.

Glossary

Additive synthesis
The formation of a color by mixing light of two or more other colors – normally from the "additive primaries," red, green and blue.

Autochrome
The first practical system of color photography, introduced by the Lumière brothers in France in 1907.

Bleach
A chemical bath to convert the black metallic silver that forms a photographic image into a compound such as silver halide, which can then be dissolved or dyed. Bleach is used in toning and in many color processes.

Blix (bleach-fix)
A combined bleach and fix bath used to shorten color processing.

Color compensating filters
Filters designated by the letters CC and used to alter the color balance of a slide, particularly to compensate for a color bias in the light source.

Color conversion filters
Filters used to adjust the color balance of a light source when it differs substantially from the color temperature for which a film type is designed. Such filters can effectively convert tungsten slide film into daylight film or vice versa.

Color developer
A chemical that develops both the silver image and the color dyes in color film.

Color reversal
A type of color film, printing paper or process in which a positive color image (usually a transparency) is produced from a scene or positive original without requiring an intermediate negative stage.

Color temperature
The color quality (particularly the redness or blueness) of a light source, measured in kelvins (k) or mireds.

Complementary colors
Two contrasting colors that produce an achromatic shade (white, gray or black) when mixed. In color films and color printing processes, the most important pairs are red-cyan, green-magenta and blue-yellow.

Contrast
The degree of difference between the lightest and darkest parts of a subject, negative, print or slide.

Couplers
Chemicals used in color film emulsions or in developers that "couple" with exposed silver halides to release dyes that form the color image.

Development
Chemical process by which a latent image on exposed photographic material is converted to a visible image.

Dye transfer
Method of making high-quality color prints by transferring dyes from three separately prepared images onto one sheet of paper.

Emulsion
Light-sensitive layer of film or printing paper. Conventional photographic emulsion consists of very fine silver halide crystals suspended in gelatin, which blacken when exposed to light. The emulsion of color film contains dye forming chemicals as well.

Exposure latitude
Ability of a film emulsion to record satisfactorily when exposure is not exactly correct. Color print films generally have more latitude than slide films.

Fixing
Making a photographic image stable by chemical means after it has been developed.

Fogging
A veil of silver in a negative or print that is not part of the photographic image. Intentional fogging by chemical means is a stage in color reversal processing.

Incident light reading
A method of measuring the light that falls on a subject, as distinct from the light that is reflected from it.

Kelvin (k)
A unit of color temperature. Daylight-balanced color films are balanced to 5,500k and artificial light films to either 3,400k or 3,200k. However, both natural and artificial light vary in color temperature; for example, an overcast sky has a value of about 10,000k, a blue sky with bright sunshine about 6,000k. See also COLOR TEMPERATURE and MIRED

Light-balancing (color correction) filters
Filters used to make minor adjustments to the color temperature of a light source.

Mired
A unit of color temperature used to calibrate color correction filters. See also COLOR TEMPERATURE and KELVIN.

Polarizing filter
A filter that changes the vibration pattern of light passing through it, used chiefly to remove unwanted reflections from a photographic image or to darken the blue of the sky.

Primary colors
Blue, green and red – the colors of light that when mixed together equally make white light and that when mixed in various combinations can make any other color. Saturated colors are "pure" colors that reflect only one or two primaries; when a third primary is introduced, the color is "desaturated" toward white, gray or black.

Push processing
Increasing development time or temperature during processing, usually to compensate for underexposure in the camera or to increase the contrast. Push-processing is often used after uprating the film (that is, underexposing by setting the camera to a higher film speed) to cope with dim lighting.

Reciprocity failure
The occurrence of an unwanted color cast in an image due to an extremely long or (less often) extremely short exposure.

Silver halide
A light-sensitive compound of silver with a halogen such as bromine, chlorine or iodine. Silver halides are the main constituents in photographic emulsion. Developers convert the latent image, which is formed by light on these halides, to black metallic silver.

Slide copier (duplicator)
A device used to make duplicates of transparencies, Bench-top copiers incorporate a lens, a built-in light source, a camera mount and a slide holder. A simpler copy tube allows you to use the camera lens and a portable flash unit.

Subtractive synthesis
Means of producing a color image by blocking (subtracting) appropriate amounts of unwanted colored light from white light. Modern photographic processes generally use dyes or filters of three colors known as the "subtractive primaries" – cyan, magenta and yellow.

Tripack (integral tripack)
Composite photographic emulsion in the form of a multi-layer sandwich of subtractive color dyes coupled to silver halides. The dye-forming layers are blue-sensitive for the yellow dye image, green-sensitive for the magenta dye and red-sensitive for the cyan dye.

Ultraviolet (UV)
A form of electromagnetic radiation close in wavelength to light. UV radiation is invisible to the eye but can affect film, sometimes causing a blue cast unless removed by a filter.

Index

Page numbers in *italic* refer to the illustrations and their captions

Acknowledgments

Picture Credits
Abbreviations used are: t top; c center; b bottom; l left; r right.
Other abbreviations: IB for Image Bank, IMP @ GEH for International Museum of Photography at George Eastman House. All Magnum pictures are from the John Hillelson Agency. All Steichen pictures are with the kind permission of Joanna T. Steichen. All Stieglitz pictures are with the kind permission of Georgia O'Keefe

Cover Michel Dufaux/Paris

Title Pete Turner/IB. **7** David Muench/IB. **8** Personnaz/Fotogram. **9** Cecil Beaton/Sotheby's, London. **10** Larry Burrows/Time-Life Picture Service. **11** Loomis Dean. **12** tl Ashvin Gatha, tr Nic Barlow, cl Ian Griffiths/Robert Harding Picture Library, cr Michelle Garrett, bl Charles Steiner/IB, br Ian McKinnell. **13** tl Krishan Arora, tr Graeme Harris, cl Dennis Stock/Magnum, cr Sergio Dorantes, bl Trevor Wood, br Ceri Norman. **14-15** Ken Griffiths. **16-17** J.H. Lartigue/John Hillelson Agency. **18-19** All Victoria and Albert Museum. **20-21** all Kodak Museum. **22** tl, tr Société Française de Photographie, br Ducos du Hauron/Jean-Loup Charmet. **22-23** Ducos du Hauron/IMP @ GEH. **23** br Ducos du Hauron/Musée des Beaux Arts/Fred Dustin Collection. **24-25** All Kodak Museum. **26** tl IMP @ GEH/The Fred Dustin Collection, tr Kodak Museum, b John Freeman. **27** tl and b Paul Brierley/Science Museum, tr Kodak Museum. **28** All Kodak Museum. **30** t Gert Koshofer, bl Antoine Meys/Institut Lumière, courtesy of Cibachrome, br Kodak Museum. **31** Institut Lumière, courtesy of Cibachrome. **32** Kodak Museum. **33** tl IMP @ GEH/The Fred Dustin Collection, tr Kodak Museum, b Luis Marden/1941, National Geographic Society. **34/35** All FWJ & KFA Brown. **36** t Polaroid (UK) Ltd, br Polaroid Corporation, **37** t Polaroid (UK) Ltd, **37** b Kodak. **38-39** Norman Parkinson. **40-41** all courtesy of The Library of Congress. **42** tl Edward J. Steichen/Sam Wagstaff Collection, r Edward J. Steichen/Metropolitan Museum of Art, The Alfred Stieglitz Collection 1955, b Edward J. Steichen/The Museum of Modern Art. **43** tl Edward J. Steichen Collection/The Museum of Modern Art, r Alfred Stieglitz/The Witkin Gallery/George A. Tice Collection, b Alfred Stieglitz/IMP @ GEH. **44** tr Personnaz/Fotogram, c Carlo Zaar/Nic Barlow, bl Balagny/Collection SFP/Fotogram/ANA from the John Hillelson Agency. **45** t Gimpel/Collection SFP/Fotogram/ANA from the John Hillelson Agency. **46** t Cecil Beaton/Sotheby's, London, b Horst P. Horst/Condé Nast Publications Ltd. **47** Anton Bruehl, courtesy of Anton Bruehl Jnr. **48** l Paul Outerbridge/The Robert Miller Gallery Inc, r Paul Outerbridge/The Nicholas V. Duncan Collection. **49** Paul Outerbridge/The Robert Miller Gallery Inc. **50** all Eliot Porter, courtesy of Daniel Wolf Inc, NY. **52** Helen and Frank Schreider/1961, National Geographic Society. **53** t John Dominis/Time-Life Picture Service, b Edwin L. Wisherd/1940, National Geographic Society. **54-55** Ken Griffiths. **57** l Tim Stephens, r Mike Newton. **58** Richard Platt. **60** John Garrett. **61** Tim Stephens. **62** Vautier de Nanxe. **65** t and r Guglielmo Galvin, c John de Visser. **68-69** Peter Aaron/Esto Photographics Inc. **70** John Sims. **71** all Richard Bryant. **72-73** l John de Visser. **74-75** r John de Visser. **76** t John Hedgecoe, b Kevin Horan/Click-Chicago. **77** Thomas Höpker/Magnum. **78** Mike Newton. **79** Tim Stephens. **80-81** c David Hockney, 1982. **85** t Michelle Garrett, c and b John Heseltine. **86-87** Graeme Harris. **88** l Ian McKinnell, r Robin Bath. **89** t Michael Manney/Click-Chicago, b Rene Burri/Magnum. **90** t John Sims, b Trevor Wood. **91** l Peter Phillips/Trevor Wood Library, r Richard Haughton. **92** tl Trevor Wood, bl John Freeman. **92-93** Robin Laurance. **94** t John Heseltine, b Robin Bath. **95** l John Heseltine, r Ceri Norman. **96** t Robin Bath, b Richard Platt. **97** Richard Platt. **98** l John Garrett, **98-99** Trevor Wood Picture Library. **100** t John Cleare/Mountain Photography, bl John Freeman, br Trevor Wood. **102** Robin Bath.

Additional commissioned photography by Toby Glanville, John Miller, Mike Newton, Richard Platt, George Taylor

Technical assistance from Tim Stephens, Frank Thomas

Artists David Ashby, Kai Choi, Gordon Cramp Studio, Tony Graham, Stan North.

Retouching Bryon Harvey, Roy McAllister

Kodak, Ektachrome, Kodachrome and Kodacolor are trademarks

Time-Life Books Inc. offers a wide range of fine recordings, including a *Big Bands* series. For subscription information, call 1-800-621-7026, or write TIME-LIFE MUSIC, Time & Life Building, Chicago, Illinois 60611.

Notice: all readers should note that any production process mentioned in this publication, particularly involving chemicals and chemical processes, should be carried out strictly in accordance to the manufacturer's instructions.